W9-CPR-076

BASIC
PHOTOGRAPHY

The **amateur photographer** guide to

BASIC PHOTOGRAPHY

George Hughes

HAMLYN
London · New York · Sydney · Toronto

Contents

Published by The Hamlyn Publishing Group Limited
London . New York . Sydney . Toronto
Astronaut House, Feltham, Middlesex, England.
Copyright © The Hamlyn Publishing Group Limited 1980

Fourth Impression 1982

ISBN 0 600 37252 9

All rights reserved. No part of this publication may be
reproduced, stored in a retrieval system, or transmitted,
in any form or by any means, electronic, mechanical,
photocopying, recording or otherwise, without the prior
permission of The Hamlyn Publishing Group Limited.

Printed in Spain

How photography works

Light is not just something which helps us to see things: it is an actual force, and like any force it affects whatever it strikes. Light is the force that tans the sunbather's skin; the same force ripens fruit on the tree, so that the cherries which are pale green in early summer begin to turn brilliant red as the sun shines on them for week after week.

Science has made us aware of how the laser beam can burn through materials as tough as steel—yet a laser beam consists of nothing more than light, although in this case it is greatly concentrated. An ordinary magnifying glass can concentrate enough sunlight to burn a hole in a piece of paper.

Light is a force, and sunlight is the most powerful force of all. But all light, even candlelight and moonlight, has enough power to affect photographic film.

Individual rays of light travel outwards in all directions from any light source, whether it is the sun, a table lamp or a match flame, and each ray travels in a straight line. When light strikes an object it is reflected, and again the rays spread out in straight lines from the point of contact. If all those rays passed straight into your eye your brain would find it impossible to sort out the jumble and you would be unable to see any detail—only a blur. Your eye is, therefore, equipped with a lens, and this lens does exactly the same job that the lens on the front of every camera does: it bends, or refracts, the rays of light, so that the image they make up is sharply in focus.

What happens when light passes through a lens and strikes a photographic film is that the light immediately begins to work changes. The film is merely a flexible material, with a gelatin paste (called the emulsion) covering one side. Suspended in the emulsion is a dense layer of silver bromide crystals: these crystals absorb the light and are chemically altered by it—they take on what is known as a latent image. When the film is immersed in a developing liquid all the crystals which were affected by the light turn into metallic silver—which, as it is metal, is opaque, and appears black when you hold the negative up to the light. Where a lot of light has struck the film there will be a dense patch of metallic silver (for example, on a sunlit face); where little or no light has struck there will be little or no conversion to metallic silver, and that area of the negative will be more or less transparent.

When a print is made from such a negative, a great deal of light passes through its transparent areas. This light falls on the photographic paper, which, like the original film, has been treated with silver bromide crystals. The light blackens these crystals so that areas which were dark in the original scene now become dark again; whereas the sunlit face, very dark on the negative, lets very little light through to blacken the crystals on the paper, and the face appears bright and sunny once again.

Colour film works in just the same way as black and white film, except that there are three layers of emulsion—one for blue, one for green and another for red.

Developing a film simply consists of bathing it in liquids to convert the crystals to silver and then to wash away the crystals which were not affected by light. It can be done with simple equipment, and is one of the ways in which the real enthusiast can control exactly how his finished photograph will appear.

Like anything else that flows light can be measured. Film and camera manufacturers have done a great deal of research into the quantity of sunlight that reaches the earth's surface under average conditions, as well as how much is given off by flash bulbs or electronic flash units. Such knowledge has enabled them to produce very simple cameras with no controls whatever. These cameras handle fixed quantities of light; they pass enough to the film to make a picture in average conditions, such as good daylight, but not enough for dim lighting conditions such as indoors, or late in the day, or in deep shade. Having more controls on a camera simply means that it can be adjusted to cater for differing quantities of light.

Below left: all stages of the photographic process rely on manipulating light. Sunlight reflected from an object is gathered by the camera lens and focused on a light-sensitive material, which records the patterns of light and shade. When this image is projected on to special paper a picture of the original scene is formed.

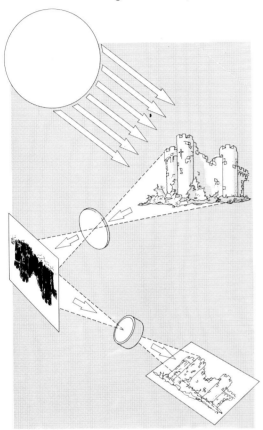

Any light is powerful enough to affect photographic film to some degree: ordinary daylight (opposite page), gloomy daylight (left) or daylight in dark old buildings (above). Artificial light— flash or domestic electric lamps, even candlelight— is also strong enough, although you may need a camera with a few simple controls.

Light—its quality

The quality of light, like the quantity, can be measured; and one aspect of this is especially important to photography. This aspect is known as the 'colour temperature' of light, and is, roughly, a way of describing what kind of light it is. For example, the harsh bright light of the midday sun in summer has a bluish tinge, and this type of light is described as having a high colour temperature. A low colour temperature indicates a reddish light.

No household bulb can possibly deliver a *quantity* of light that approaches the sun's output; but a 100-watt bulb in your living room might very well match the *quality* of light at sunrise and sunset.

Photographically, this quality business is very important. For films cannot be made to adjust to the differing quality of light in the way that cameras can be made to adjust for variations in quantity. Ordinary colour films are balanced by the manufacturers to give accurate reproduction of colours under both average summer sunlight in the middle hours of the day (between 10am and 3pm) and when used with electronic flash or blue flash bulbs and cubes.

There are ways of compensating for too much redness or blueness in the light, either by using filters on the camera lens or by correcting the over-emphasis when making colour prints in the darkroom. Professional photographers will often use one of these control devices to make sure that their pictures are neither too red nor too blue. But in so doing they are actually destroying the natural quality of the light—or at least counteracting it.

Knowing something about the quantity of light helps you to take a properly exposed picture. But understanding the quality of light will help you put atmosphere into your pictures.

But why should light change colour as the sun rises and sets? Because the atmosphere surrounding the earth actually scatters the ultra-violet and blue content of sunlight. When the sun is low on the horizon the light, coming in at an angle, has to travel further through the atmosphere than when it is directly overhead. A greater proportion of the UV and blue is scattered: it becomes ineffective and the light reaching the surface of the earth contains a greater proportion of red.

Whenever we take a photograph we do so by reflected light. The sunlight, or the light from a flash bulb or whatever, first hits the subject and is then bounced back through the camera lens on to the film. Light will take on the colour of whatever it is reflected from or passes through. If you photograph someone beneath a shady tree on a bright day the face will appear greenish-blue—blue from the open sky and green from the canopy of leaves. A

Right: the light from the sun at dawn and at sunset is distinctly red in hue—this is because it has to travel further through the atmosphere to reach us and much of the blue content of light is scattered on the way. However, we are so accustomed to this effect that we tend not to notice it, and are often surprised when pictures taken at these times turn out to have a bright orange-red colour cast. All the same, the effect need not be unpleasant. Once you have learned to recognize the so-called 'colour temperature' of light you can exploit it to give your photos atmosphere.

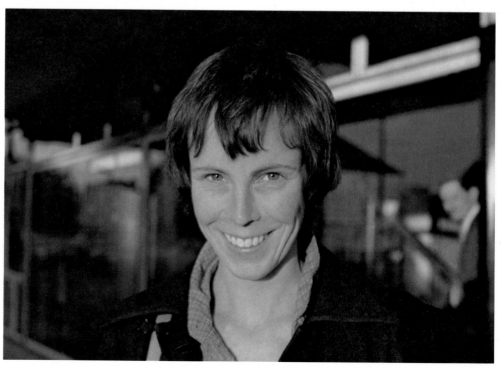

greenish-blue face is not necessarily unpleasant—nor is any other colour cast, as long as it is quite evident in the photograph that the odd colour is in keeping with the surroundings. A portrait taken by candlelight would be expected to have a reddish colour—and this would give it a pleasing atmosphere of warmth and softness.

Many fine pictures depend for their effect on their mood, or atmosphere, and the way to create this, apart from regulating the quantity of light which will reach your film, is to take steps to exploit its natural quality.

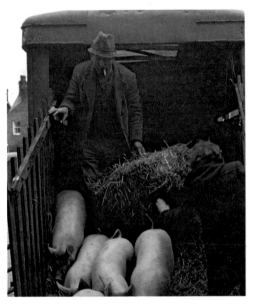

Above: in the cool interior of a Tokyo art shop a mixture of fluorescent tubes and daylight filtering through windows creates this greenish-blue tinge.

Centre left: the pink light of early morning enhances the colour of the pigs' skin.

Centre right: daylight film is balanced to record colours correctly at midday in summer—hence the crisp clarity of the colours in this photo.

Left: the reddening sky begins to impart its own colour to the rest of the landscape. Since the sky is part of the whole picture the hue it gives to the rest looks entirely natural.

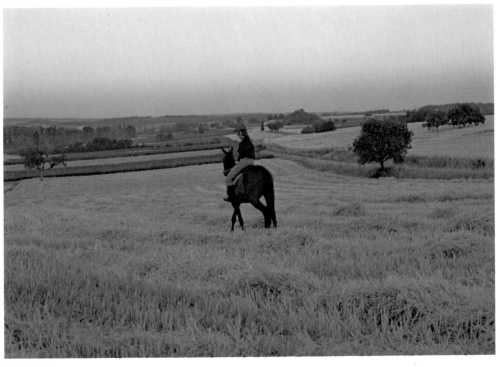

Different types of photograph

There are basically two kinds of photograph: in the first, the subject is all-important; in the second, it is the overall impression of the shapes or colours within the picture that matters. The first kind may show a baby's smile, a soccer star scoring a goal, a racing car crashing—*something happening*. The photographer's intention is to show what is happening, and if he misses the vital moment his picture is useless. In this kind of picture it does not matter at all what is in the background as long as he shoots at the right moment.

The second kind of picture demands that the *whole* impression is pleasing, and that nothing in the background is distracting, confusing or ugly. To satisfy that second need you will have to use your artistic sense; for the first you will have to be able to work quickly. And both *can* be found together in the same picture.

Very old photographs sometimes fetch large sums of money when they appear in auction rooms. And quite often they are very poor in terms of technical quality—either because of the limitations of the equipment and processes used by the photographers, or because the pictures themselves have become faded and stained with time. The very early cameras were no more sophisticated than even the simplest of today's little pocket cameras, and early developing and printing was often much less satisfactory and consistent in quality than you get from your local photo shop. The high value placed on old photographs usually stems from their rarity—as with other antique objects. But, increasingly, a great deal of interest is being shown in old photographs for no other reason than that they *are* old. Especially interesting are the contents of vintage family albums and old collections of postcards. These are simple snapshots often enough, but what a great deal they show of the past! Costumes, the appear-

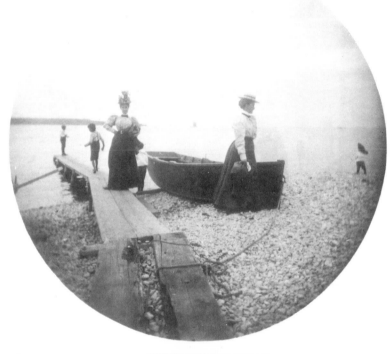

Above: a Kodak snapshot, taken about 1888 when film began to replace glass plates—an interesting record of dress styles.

Right: a shot in which the photographer has had time to compose the image with care—there is nothing moving in the picture. It was taken for its own sake, not because the photographer wished to record a particular event.

Left: a simple snapshot, taken indoors. There is no reason to believe that a snapshot is always something second class, to be snootily dismissed as the hamfisted effort of an ignorant beginner.

ance of towns and villages, the design of old vehicles, the way of life of our ancestors—all these are fascinatingly paraded in the old snapshots. And a whole book publishing industry thrives on them.

Your snapshots, however simple, will become the historic documents of tomorrow, and your children and grandchildren will treasure them. But you will give much more pleasure—and information—if you not only develop both quick reactions and an eye for design, but also make your pictures of a good technical standard.

The best way to reach a higher standard is simply to look at many pictures and compare their qualities with your own. You will notice that newspaper pictures of dramatic happenings are sometimes very poor in quality, even though the photographer may have used equipment costing hundreds of pounds. In such pictures the reason is usually clear: the cameraman had to shoot very quickly or he would have missed his picture. Nowhere was there a very good quality photo of the tragic assassination of President Kennedy in 1963—such events are over in moments, and there is no second chance to get a better picture. Whatever the camera settings and whatever the likelihood of blur and unsharpness the press photographer must grab his shot instantly.

Compare such pictures with the high quality of photography in books and magazines, and at exhibitions. These are pictures in which the photographer has obviously had all the time in the world to choose exactly how he will arrange his subject and his equipment.

Below left: another snapshot—this time one with a real sense of occasion. Such a picture is ideal for the family album and could be a source of pleasure for many years.

Below: quick reactions and an eye for composition were both needed for this picture. A moment's delay and the opportunity would have been lost; a slightly different relationship between the two figures—cow and girl—and the humorous appeal would vanish.

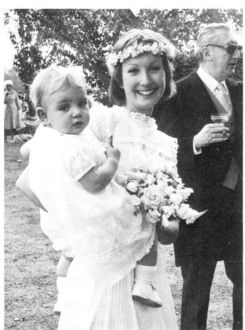

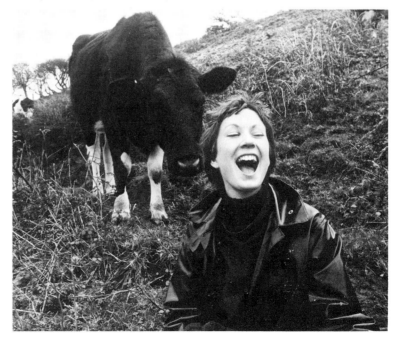

Why different types of camera?

Different types of photograph impose different requirements on the equipment used. Below: good pictures of buildings can be taken with most types of camera.

Below right: a 35mm rangefinder camera.

Opposite page, bottom right: flowers are a more demanding kind of subject, especially in close-up. A 35mm single lens reflex camera would be a good choice here.

Since all cameras do the same basic job of focusing light rays on to sensitive film, why are there so many different types? A look at the history of camera manufacture can help to explain.

The earliest cameras were made like wooden boxes, with a simple lens at the front, but no shutter. They were loaded with sensitized plates of glass instead of the more convenient film used today. The plates had a fixed sensitivity and were frequently prepared by the photographer himself, to his own formula. The only way to control the amount of light reaching the film was to remove the cap from the lens for the length of time required.

This arrangement was satisfactory for subjects in which nothing moved, such as landscapes or buildings. But because the lens was restricted, and because the plates were slow to react to light, it took a long time to make a photograph. And if trees shook in the wind during exposure then they just appeared blurred in the picture; and flowing water blurred too, giving rivers, waves and fountains a strange, smooth, plastic appearance.

Plates were soon made more sensitive, so that they took up the image more speedily; and a mechanical shutter was introduced to uncover and cover the lens opening. The shutter might open for 1/25th of a second, or even as little as 1/50th of a second. Portraits could be made in good daylight, or by the bright flash caused by igniting a tray full of magnesium powder. That is the stage at which very simple cameras stand today: they have one moving part only—a shutter opening for a fixed period of between 1/40th and 1/80th of a second—and a non-adjustable lens, and are capable of taking acceptable pictures only in good daylight or by flash.

Slower shutter speeds, uncovering the lens for ¼, ½ or a whole second were introduced, allowing light to pass through the lens and on to the plate for enough time to make pictures in quite poor light. But they were not much good for moving subjects. As lens quality improved less restriction of the light passing through the centre was necessary; and for the same effect on the plate the shutter would need to be open for less time. Cameras now had lenses with variable apertures and shutters with variable speeds. By using a large lens aperture and a fast shutter speed action pictures could be taken even in bad light. Many of today's inexpensive cameras will perform that task too.

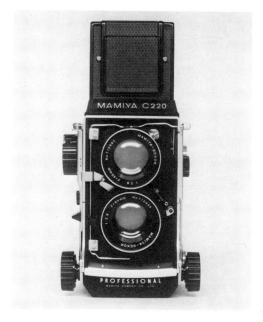

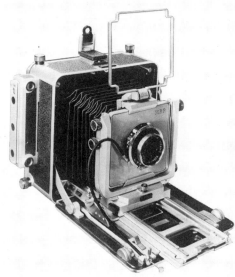

Far left: a twin lens reflex camera. This one has interchangeable lenses and is very popular for studio work, but is not as versatile as single lens reflex cameras.

Left: a view camera — slower to use than some other types, but giving exceptionally high quality results.

Below left: a very simple model, the Kodak Instamatic 28. The two symbols above the lens represent different aperture settings for dull and sunny weather.

But a lens, to perform at its best, must be able to move backwards and forwards, to bring into focus objects at any distance from it. Lenses with rack and pinion movement, or screw-thread focusing, were early developments in photography. And a lens which focuses allows the photographer to choose exactly which part of his scene shall be the most sharp, while a fixed-focus-lens does not.

Even before all these refinements were introduced there were many people who wanted cameras to be portable, and the process of miniaturization began. The glass-plate cameras were big and cumbersome, and flexible film, rolled on to a spool, proved much lighter, more portable and very popular. With film came smaller negatives, which could be enlarged (whereas the glass plates were contact-printed on to a paper of the same size). Nowadays there are five negative sizes in general use — and the smaller the negative, the smaller the camera needed to make it. The tiny cameras which make 110 negatives no bigger than a finger nail can be even smaller than a cigarette packet.

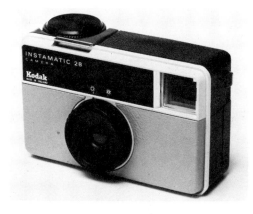

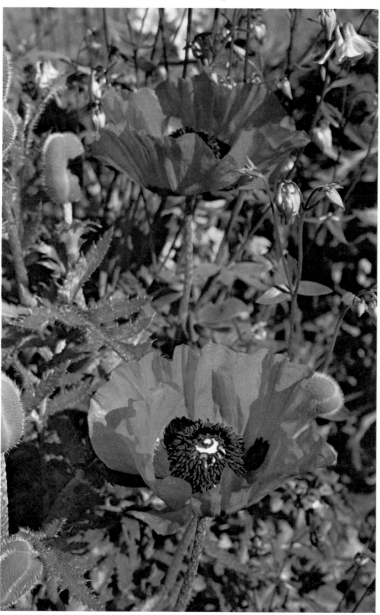

Modern cameras

In 1924 Oskar Barnack invented the Leica, which was the first 35mm camera, and thus laid the foundation of photography as we know it today. Barnack's Leica had variable shutter speeds, variable lens apertures, and the lens focused by means of a rangefinder. But the most important feature of this solid little instrument was that it could have its standard lens removed and a telephoto or wide-angle lens substituted. This interchangeable lens facility allowed the photographer either to show a bigger area of the scene before him (with a wide-angle lens) or to select a smaller portion of the scene and make that bigger (by using a telephoto lens). Photographs could now be taken in just about every light condition, of fast-moving subjects, and of subjects some distance away. With the interchangeable lens facility came more exciting news photography, fast-action sports photography, better pictures of wildlife subjects, and in general photography became much more versatile.

Two problems remained unsolved with the Leica and similar rangefinder cameras which followed. The rangefinder worked only with relatively low-magnification telephoto lenses (the limit is 135mm, which gives less than 3× magnification over the standard lens); and what the photographer saw through the viewfinder of the camera was not *exactly* the same field of view as the lens 'saw', since the lens was a couple of inches to one side of the viewfinder.

Both these problems were solved with the introduction of the single lens reflex camera, or SLR. By means of a mirror and a prism the SLR leads the light entering the lens through several angles to the viewfinder eyepiece; the photographer sees exactly what the lens sees, and more careful and precise composition is possible. And since the focusing mechanism— usually just a screw thread—is built into the lens alone very long lenses can be used. A lens

Below: the Hasselblad. Expensive to buy, this camera is nevertheless very versatile and is the choice of many professionals and dedicated amateurs.

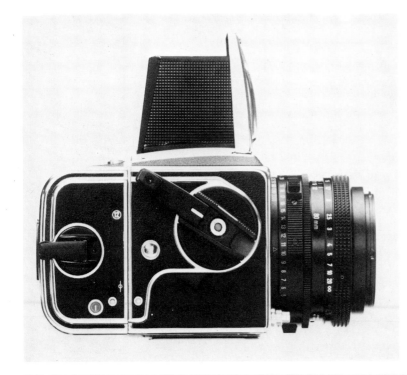

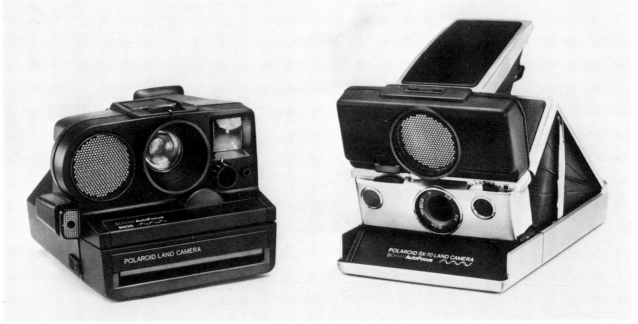

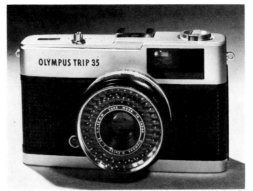

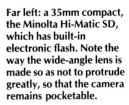

Far left: a 35mm compact, the Minolta Hi-Matic SD, which has built-in electronic flash. Note the way the wide-angle lens is made so as not to protrude greatly, so that the camera remains pocketable.

Left: another popular 35mm compact, the Olympus Trip 35. This has a built-in exposure meter clearly visible round the lens.

of 500mm, such as is often used by sports and wildlife photographers, magnifies the subject ten times when compared with the 50mm lens fitted as standard to 35mm cameras. Not surprisingly, the single lens reflex is highly popular.

The 35mm negatives and slides are so high in quality that some manufacturers have designed small pocketable cameras, called compacts, to provide them. The compacts usually have a focusing lens, but not the interchangeable lens facility; further, to make them even more compact the lens is restricted in actual physical length and has to be designed as a moderate wide-angle. Such cameras provide excellent holiday pictures, and sell in large numbers, but the need to get rather close to the subject (for it to appear a reasonable size on the negative) is a minor drawback, and is one reason why many people still prefer a single lens reflex, with its adaptability for different lenses.

Since good quality pictures depend on the right amount of light reaching the film, many people use special light-measuring instruments called exposure meters to remove the guess-

work. To save time and trouble camera makers began to build meters into the bodies of their cameras, a practice which has reached the height of sophistication in the all-electronic through-the-lens metering of modern SLRs. The modern SLR allows its user to choose either the lens aperture (most popular) or the shutter speed; whichever he chooses the camera electronically selects the other. Some cameras, especially the little 35mm compacts, are so automatic that they select both shutter speed and lens aperture—they are said to be fully programmed, and give the photographer no choice. They will certainly provide correctly exposed pictures, but are disliked by some people who prefer to choose their own camera settings.

So, the huge variety of cameras on the photo-dealers' shelves exists because people demand different facilities from their instruments. The aim of this book is to help you to decide what you want from a camera, and to provide you with enough knowledge about photography to help you produce the best results no matter which type you are using.

Opposite page, below: two Polaroid instant cameras, the compact Polaroid 5000 Sonar AutoFocus (left) and the folding SX70 Sonar AutoFocus Land cameras. Although they are sophisticated pieces of electronic wizardry these cameras are extremely simple to use. However, it is worth bearing in mind that if you take a picture through a window with a sonar focusing camera, it will focus on the glass and not on the subject. Nevertheless, this type of camera is a great blessing if you do not like fiddling with knobs and dials.

Left: the Pentax, a popular modern single lens reflex camera, pictured here with three of the interchangeable lenses designed to fit it. Ranges of lenses are made by manufacturers for their own cameras, but the SLR is now so universally popular that independent makers have produced ranges of lenses which will fit most SLR cameras.

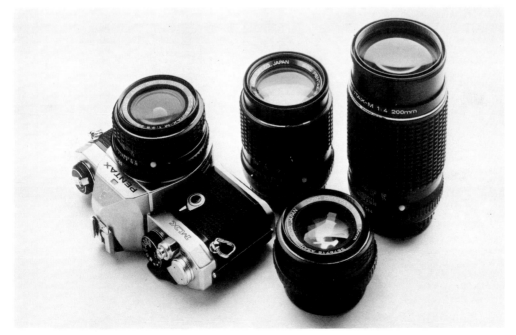

Instant photography

It was in 1947 that an American, Dr Edwin Land, introduced the Polaroid Land Camera. This produced instant black and white prints about the size of modern enprints; but it was another fifteen years before instant colour prints could be produced.

Right: the best-selling model 1000, the simplest Polaroid model designed to use SX70 packs, which provide a dry, finished colour print in seven or eight minutes. It is shown here with a Polatronic flash unit.

Far right: Polaroid film, showing the peel-apart system. The rollers at the front burst pods of chemical fluid as the paper is drawn out.

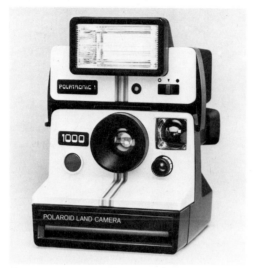

Until the mid 1970s the Polaroid Land Cameras used the peel-apart system. The user took the photo, and then pulled the exposed film out of the camera from between two metal rollers like the rollers of a clothes wringer. The rollers burst pods of chemical fluid within the

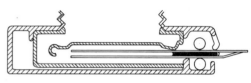

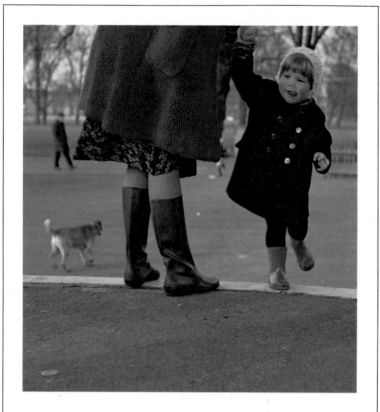

film which immediately began to develop the image. After a minute or so the user peeled away a protective covering, and there was the print. The peel-apart system is still in use, but it has become outdated since the introduction of the much cleaner Polaroid SX70 system. Similar systems have been introduced by Kodak, and are being developed by other manufacturers.

The new instant photography system sends a print rolling out of the camera immediately the shutter is pressed; the print then begins to develop, in full colour, right in front of the user's eyes. After a few minutes the development is complete. The print is dry, and protected by a hard glossy coating. The Polaroid SX70 system produces a square print of 8 × 8cm (a little larger than 3 × 3in); the Kodak system produces a picture of similar area, but rectangular in shape.

Instant photography at a more sophisticated level—with more involvement by the photographer—has been taken up by professionals and by artist photographers. But the SX70 and similar systems are enormously popular with amateurs. The cameras used are provided with automatic exposure control, although a lighten/darken control allows the user a certain amount of discretion. Polaroid have produced a model which focuses automatically

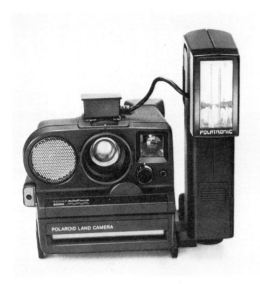

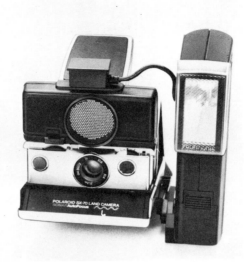

Left: Polaroid Land cameras, the same models as pictured on page 20, but shown here fitted with Polatronic flash units. Electronic flash is simpler to use than bulbs, and is now taking over across all levels of photography.

too, by sending a sound signal from camera to subject and measuring the length of time the signal takes to bounce back.

The instant film packs provide a set of finished prints—no negatives. But it is a simple matter to have particularly good pictures copied, and even made into enlargements. In all other ways the instant photography process should be treated like any other—with the same care being taken over composition, choice of subject, lighting, and avoiding the errors and problems which crop up in all forms of photography.

Instant photography is ideal for family album pictures, and when used with flash, pictures can be taken in all conditions. But there are a couple of points to be particularly aware of. First, you must be very careful not to get your fingers in the way of the picture as it emerges from the camera—if you do disturb its progress you will probably have to discard all the remaining exposures. Secondly, the lighten/darken control is only a form of exposure control. It will make your *entire* picture either lighter or darker but cannot alter the contrast between parts of the picture.

Instant photography is becoming ever more sophisticated, and there are certain to be more developments in the future. Already Polaroid have marketed an instant ciné system, which allows the screening of a movie only two minutes after shooting. And instant still cameras do have one unique advantage: they offer a first class method of learning about photography by your mistakes. Professionals often take an instant picture to check their lighting set up and balance before going on to shoot with conventional materials. You can do the same, to check on composition and colour arrangement, for you can take a second picture

only minutes after the first, when you have had a chance to identify any errors. The snag is that instant film packs are quite expensive, but once you have bought a film pack there are no further charges for developing and printing.

At present instant film is less sensitive to light than the most sensitive of the conventional colour films, and so is less effective in poor light conditions unless flash is used.

Below and opposite: SX70 prints (larger than actual size).

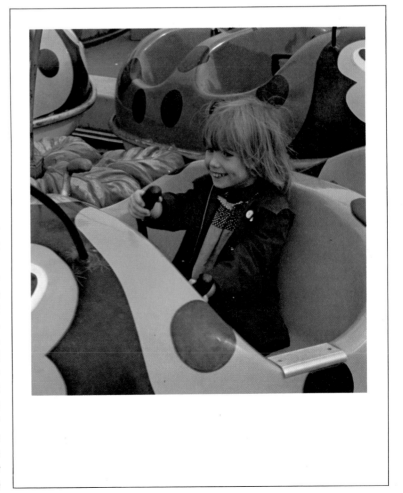

Composition—the shapes within your photographs

Composing a black and white picture simply means arranging the shapes and tones within it in a pleasing pattern. But it is not always easy to 'arrange' things. After all, you cannot move mountains, trees and buildings, or clouds and the sun. But you can move around yourself, and you can decide how much of the scene before your camera to include or leave out.

Firstly, what is a good composition and what is a bad one? A good one looks well-balanced and is not cluttered and fussy: there is nothing to make the eye restless, so that it tends to wander away out of the photograph altogether.

Good balance is evident when the picture does not seem lop-sided or top heavy, as it might if all the heavy, dark tones were crowded into one part. For example, imagine a picture of a park, delicately shrouded in the morning mist; the overall impression is one of soft grey. A nearby tree, heavy and dark, crammed over to one side, would unbalance the picture; but add to this the dark silhouetted shape of, say, a man walking his dog at the other side of the picture, and it becomes balanced again. And a portrait in which the subject's face seems to be part of a fussy background of jutting branches and twigs and lamp posts would be confusing; picture him against a very even unobtrusive background and the result is instantly better.

It often happens that a picture of some fine old building or open landscape suffers because there seems to be no border to the picture—it has no natural boundaries to contain the viewer's eye and keep it travelling around the area of interest. Here, natural boundaries can be provided by including a framework of overhanging trees, by shooting through an archway, window frame or doorway, and including part of these in your picture.

There are far more ways than one to take any photograph, and if you move around the subject you may find an even more appealing viewpoint than the one which first attracted you. Just a step or two to one side or the other could bring other interesting elements—perhaps just the leaves of a framing tree—into the viewfinder.

This business of balance in composition is very important and really does make a difference to the way a viewer reacts to your photographs. The way you arrange your subject will automatically put certain ideas into the viewer's mind. For example, a portrait in which the head is placed high up near the top of the picture will suggest that the subject is haughty, powerful, self-contained, perhaps even arrogant; the same head placed low down would look much more vulnerable. A landscape in which the horizon slices right across the centre of the picture is indecisive; but if it is placed high in the picture it creates a feeling of tension, while placing it low introduces tranquillity and a sense of wide open spaces.

If you have a camera on which the lenses can be changed, this provides you with another aid to good composition. With a wide-angle lens, a standard lens and a telephoto lens you have the possibility of varying the relative

Below: a diagonal composition will often look dynamic, especially if the picture is upright. Here the eye travels easily from the old lady with the stick down to the foreground.

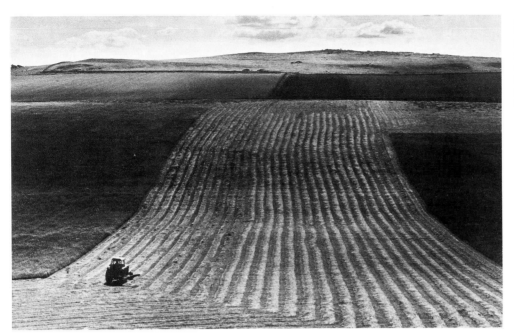

A high skyline combined with the powerful upward sweep of the lines of stubble give this strong composition a restless energy, emphasizing the smallness of the man in his tractor.

sizes of separate objects in your pictures, and thus the way in which they balance each other.

Both portraiture and action photography impose compositional requirements of their own, and these should be ignored only when there is a very good reason—which will not happen very often.

Good composition is therefore a combination of several things, all of which combine to make the picture well-balanced and make the arrangement of the subject seem logical and in keeping with the surroundings. There will be exceptions from time to time, as there are with any 'rules'—but these will be very rare.

Above: using perspective to suggest scale. The strong converging lines of pavement, street and buildings draw the eye towards the centre of the picture, where the off-centre placing of the figure helps to make her seem small and insignificant. Imagine her right in the middle instead, where the lines converge—the effect would be very different.

Left: another diagonal composition, but the effect is not a bit like that of the photo on the opposite page. The eye is led gently away to the horizon; the mood is in keeping with the subject and format of the picture.

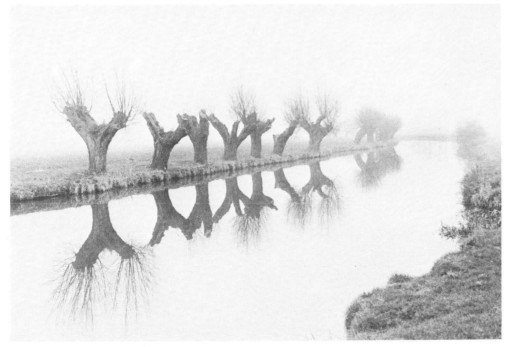

Composition with colour

For as long as photography had been in existence experiments aimed at producing colour pictures were being performed, but it was not until the early years of the twentieth century that the first really successful colour pictures were made. Modern colour film produces a very accurate reproduction of the colours of the world around us. But the requirements for pleasing balance are not the same as in black and white photography. Some colours—bright purple and orange, for example—clash together outrageously. Other arrangements, such as brown with gold and certain blues with soft brown, are very pleasing. The effect of colour is both psychological and physiological. This is why people feel good in the green and gold and blue of summer, and during the russet-leaved days of autumn. And a misty morning makes a peaceful impression—pearly grey, perhaps with a hint of gold sunlight coming through. Contrast these restful colours with the bright red rag the toreador waves at the bull—harsh, brilliant, aggressive.

Colour sets mood, and it does this more effectively in photographs than in real life, since a picture is a small selected piece of the area around the camera, and can exaggerate the amount of colour. Good colour photography relies on more than just an interesting subject; it also requires a pleasing mixture of hues, or a predominance of one. But some colours, particularly red, are especially dominant when seen together with others. Even a small area of red will claim a great deal of attention—and a tiny figure in a red dress or coat, set in a beautiful green landscape, will divert all attention away from the landscape.

Subdued colour is often the best colour. The viewer can then appreciate the subject for itself, without being distracted by colour appearing in the picture for no other reason than that it is colourful. In particular, landscape and woodland pictures which have an overall impression of gentle green or golden-brown are very satisfying. Nature's own col-

An unusual view of a window in London. Note how the photo lacks harsh contrasts and strong lines, relying instead on the subtle mixture of hues for its effect. The uneven surface of the water breaks the outlines down into areas of soft colour. Black and white composition needs distinct shapes; colour composition does not.

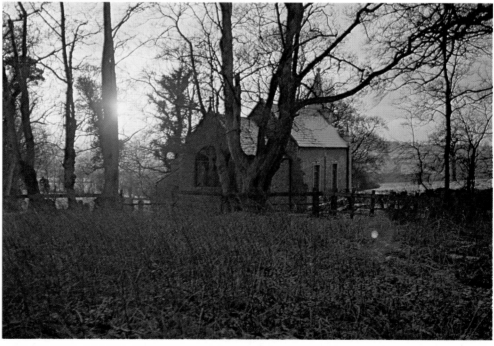

Nature can nearly always be relied on to provide peaceful colours. Here the atmosphere of a late afternoon in winter has been perfectly caught by the camera.

ours automatically impart a peaceful mood to any picture.

Green also provides a remarkably good background colour for portraits—as long as it is a soft green or a dark shade, *not* a bright acid-green. It is especially good for portraits of girls and children. Brown is often better as a background for men, seeming less soft, more masculine.

Colour has a potentially dangerous quality which it is important to be aware of: it will impart its own hue to objects close to it. If you take a portrait of someone leaning on the bonnet of a red car in bright light, then red light will bounce up into the face—giving you a subject looking like a lobster! In real life your mind discards this coloured light and adjusts what it sees to represent normality. Photographic film makes no such adjustments—it records all light faithfully, whatever its hue, and as a result will often make accurate but unnatural impressions. That may not matter when your portrait faces are tinged with a soft green by the light beneath a shady tree—as long as enough of the surroundings are included in the picture to make it clear to the viewer what is going on; but a close-up of a face tinged in this way will look awful.

Remember that only rarely is colour a subject in itself: colour is simply the way light dresses up the world. Always choose your subject primarily for its interest, and then think about the emphasis of the colour, and whether it needs softer treatment. And avoid clashing colours which will only confuse and irritate your viewers.

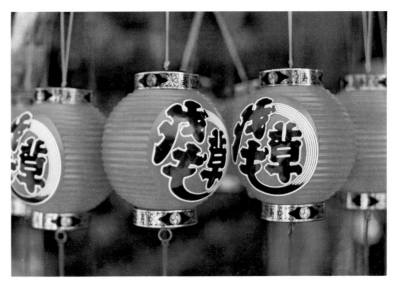

Above: bright lanterns in Tokyo. Red is an aggressive colour and will always appear to come forward from the picture. In this case the graphic effect of the oriental lettering could make a strong composition in black and white, but the bright colours are in keeping with the festival atmosphere.

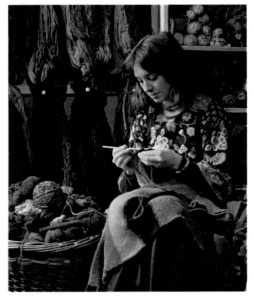

Centre: although there are many bright colours all jumbled together in this picture, the photographer was careful to expose for the highlights and not the shadows. This helps to tone down the colours, making an impression of warmth and intimacy—almost of mystery.

Left: an example of a subject that would lose all interest in black and white—yet the photo is not overloaded with colour for its own sake. It is always worth experimenting with interesting effects.

Begin with portraits

What we aim for in a portrait is an *impression* of the person in the picture. At its simplest, that can be a frontal view of the face—a map of the face, so to speak. It is not essential that a portrait should have a head and shoulders filling the picture area, although the composition of the picture should be as carefully organized as that of any other kind of picture.

Direct sunlight on a face will seldom produce a pleasing effect. There will be too much contrast between the shadows and the brightly lit parts, or highlights. Every wrinkle, every blemish will show up: the pupils of the eyes will be as tiny as pinpricks—and eyes are much more appealing when the pupils are larger, as they are in dimmer light. Bright sun will cause the subject to screw up his eyes, and the effect of this is not pleasant either. If at all possible, avoid direct sun. Much more pleasing is diffused light, such as when there is thin cloud cover or a haze to scatter and soften the sun's rays. Failing that you can take portrait pictures in the shade, or with the subject's back to the sun.

What shadows do to a face is known as 'modelling': they give it shape and added interest. But if the shadows are too dense they will have the opposite effect and obscure the detail that adds interest. Sunlight at midday comes from almost directly above, and will throw the eye sockets into deep shadow (so will any light that is placed too high).

If you take colour pictures very early or very late in the day you will get a reddish tinge, and that can make your subject look painfully sunburnt. Here we must consider a very important aspect of photography: it is that all photographs are illusions. They may *seem* to show reality, but in fact they do not—at least, not the whole of it. When you stand there with your camera you are aware of everything around you: there is a temptation to believe that people who see your pictures later will be aware of everything too. But this will not be so. Do not be seduced by the atmosphere around you: concentrate on what is clearly seen or

Portrait subjects do not have to sit still or stand around like tailors' dummies—this picture of film maker George Harrison Marks was taken during an animated conversation while he was directing and acting in one of his productions.

The word 'portrait' suggests something rather precious, a bit far removed from the idea of a simple snapshot, which can in fact make a very good portrait. Aim simply for a good likeness of the person portrayed. Do not make a big performance out of taking someone's picture—you will only succeed in making them feel awkward, and this is sure to show in the finished picture.

suggested in the viewfinder, not what you can see or hear or feel around you.

Very few cameras have an entirely accurate viewfinder. Only one or two high-precision models show exactly what is going to appear in the picture—most show a good deal less. This can sometimes be an advantage in that it helps to prevent another common disaster— that of cutting the tops off people's heads. But if the viewfinder shows only part of what is actually going on to the film there is a tendency for the photographer to move too far back from the subject, so that it comes out too small in the final picture. As a rough guide, about 3 metres (9-10 feet) is a reasonable distance for most portraits, when using a camera with a standard lens and no other attachments. Of course, negatives can be 'cropped' (unwanted areas left out) during enlargement; but the greater the enlargement the greater the sacrifice of quality and sharpness, so it is obviously best to get portrait subjects the right size at the start.

Self-consciousness is perhaps the biggest problem that has to be tackled before you can start producing really satisfactory portraits. Many people clown about when a camera is pointing at them, simply because they are embarrassed. Others just stare stiffly and anxiously at the camera. You may need a little time to put your subjects at ease. Do not make a big performance of taking their picture—but do try to show them that you know what you are doing, and show some authority if necessary (think of how a wedding photographer has to bully those big groups into position). It is never a good idea to shoot just one single picture of a portrait subject; try a few alternative poses— but keep the poses natural, so that your subject feels relaxed and not foolish.

Do not ask people to look at your camera for ages while you fiddle with the controls—this will put a strain on them and lead to self-conscious pictures. Look for the natural moments; get your camera and your position sorted out, then shoot quickly.

A good way to take a portrait of a child is to prefocus your camera and be ready to press the shutter release as he or she comes towards you. This has the added advantage that the child is more likely to look natural; carefully posed children often seem to lack personality. Note how well the figure stands out against a dark, out of focus background.

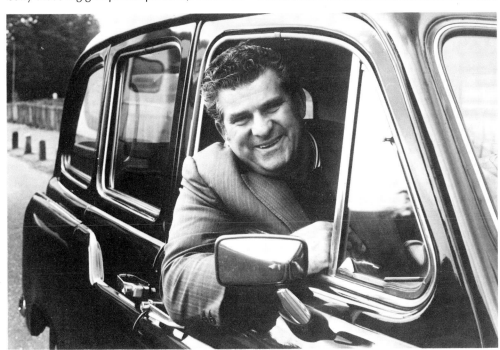

People often feel more relaxed when photographed in their own surroundings, rather than in a formal studio. The gleaming cab provides a natural framework for this portrait of a London taxi driver, and there was no need to ask him to strike any special poses.

Taking portraits indoors

Daylight coming in through a window is quite bright enough to take portraits by, and has definite advantages over artificial light. Below: bright daylight can be strongly directional, rather like a spotlight, especially if the curtains are drawn to admit only a narrow beam. The subjects are illuminated but the patterned wallper is not— if it were it would spoil the picture. Also, the photographer did not need to change to a special tungsten film.

Below right: the further you move your subject from the window, the softer the shadows become, although it will be necessary to increase the exposure or use a faster film. This was taken on 400 ASA film.

Of all the important steps photography has taken in recent years, perhaps the most directly valuable has been the introduction of high speed (better sensitivity to light) colour negative and transparency films. We have long had high speed black and white films which, with the right camera, allow snapshots to be made indoors—even by room lighting—as easily as outdoors. But colour has been the big growth area of the past decade, and is now far more popular than black and white among amateurs. And at last colour has caught up with black and white in sensitivity. The sensitivity of a film is described in its ASA value— the higher the value the more sensitive the film, and a doubling in the number means a doubling in sensitivity. 400 ASA (the letters ASA stand for American Standards Association) is considered fast—or highly sensitive.

It has always been possible to take pictures indoors—indeed in any low light level situation—by using flash. The drawback with flash is that it does not allow you to see in the viewfinder exactly what you are getting; you have to be quite an expert to visualize the finished picture. Flash lighting can also be very harsh, and consequently unkind to faces.

Especially attractive for indoor portraits is daylight which filters gently in through the window—as long as it is not direct sunlight, which will also cast harsh shadows. A window admitting soft light is as good as having your own studio.

The best way to begin with indoor portraits is to start with a member of your family or a friend who has a bit of patience. Ask him or her to sit very close to the window, then about 1 metre (3-4 feet) away, then 2 metres (6-7 feet) away, and so on. Look carefully at your subject all the time, observing the shadows on his face. Then do the same thing over again, but with the curtain partly drawn, so that only a slice of light is admitted, like a spotlight. Have the subject turned slightly towards the window so that you do not just get one side of the face lit; in particular make sure that there is a catchlight (a reflection of the window) in both eyes—for eyes are vital in a portrait to give a lively look to the face.

A great advantage of taking portraits indoors is that you will be able to picture people in surroundings amongst which they are familiar, which greatly adds to the interest of your photos. People are more at their ease, too. But, just as in outdoor shooting, watch out for fussy backgrounds (especially jazzy wallpaper,

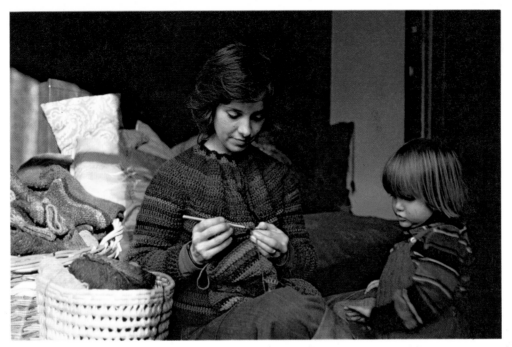

Left: direct sunlight can throw awkward shadows and cause people to screw up their eyes. To overcome this difficulty the subjects in this picture were placed out of the direct rays of the sun, and are in any case not looking at the camera. Such a compromise is necessary when for one reason or another the sun is the only available light source.

which is ruinous to portraits). Another advantage of shooting by window light, particularly if your subject is fairly close to the window, is that the background will more often than not come out quite dark, and consequently will not be obtrusive.

Daylight does, of course, fade. But with the fast films available now you can take pictures even by the light of a reading lamp. Provided your camera can be adjusted to about 1/30 second and f/2·8, you will have no trouble with 400 ASA black and white film; but if you are using colour remember that household bulbs are very low in colour temperature, and give out a reddish light. That will not matter too much if you want a relaxed and 'moody' picture, obviously an indoor shot, and perhaps with a table lamp in the picture as well; but it will matter if you work by a central ceiling light which does not appear in the picture—for then your subject will have a red face for no apparent reason. Apart from this the light, coming from high up, will cause ugly shadows beneath eyebrows and nose.

In all portraits it is wise to begin by adopting a standard of lighting which will guarantee pleasing results. And that is what you will get if you aim at having your light source (sun, window, lamp) a little above your subject, in front of him, and a little to one side. That arrangement will throw the face into pleasant relief; become familiar with this simple arrangement first—then experiment later.

Centre: portraits can be taken by window light even on dull rainy days—in fact gloomy weather provides a gentle, diffused light which many people prefer. The subject may need to be quite close to the window.

Below: taken by artificial light, this photograph has all the atmosphere of Christmas. The decorations on the Christmas tree in the background are out of focus to prevent distraction.

How flash works

So far flash has been mentioned only in passing. It is actually a very important part of photography—for a small flash unit is a portable light, available anytime, anywhere. It can solve many problems, and it can certainly help you to produce a picture under circumstances in which it would otherwise be impossible. But its light can vary in quantity and in quality, just like any other kind of light.

Electronic flash is far and away the most common type, except on the very simplest cameras, and if you go out to buy a new camera or flash unit you will almost certainly be offered electronic flash rather than the earlier bulb flash units or cubes.

The light from an electronic unit is very similar to noon sunlight in quality, in that it has a high colour temperature. Therefore, when used together with domestic lighting it will give you natural colours rather than the reddish tones you would get from domestic lighting alone.

Electronic units designed for amateur use are usually quite small, sometimes no larger than a cigarette packet. Into that small space is crammed the circuitry, batteries, a fluorescent tube and a capacitor. The capacitor, charged by the batteries, builds up a high voltage; when the unit is fired it sends this charge through the fluorescent tube, which flashes brilliantly. The differences between the several hundred models now on the market are in the brilliance of the flash and its duration, in whether the flash is of the computer variety, and in how long it takes for the capacitor to recharge (called recycling) ready for the next flash.

A small unit, adequate for indoor portraits and small groups, may have a flash duration of 1/2000 second and take about 8 seconds to recycle. But a computer unit will have varying periods of flash duration. The computer flash, or auto unit, has a light-measuring cell built into it, which monitors the light being reflected back from the subject. If the subject is bright a good deal of light will reflect back, and the unit will switch itself off after only a very brief flash—perhaps 1/20,000 second. A dark subject, or one a longish way off, will reflect less light and the unit will remain switched on for as much as 1/1000 second or more.

Computer flash will probably become the most common type in the future, but there are still some manual units which require the user to work out the exposure, and allow him to use the unit only to lighten shadows, as against using it as the sole light source for the entire scene. All units have a guide number, which is the measure of their power, and it is particularly important to understand the guide number system if using a manual unit.

Light from a small unit falls off in strength very rapidly, and the guide number indicates how much you need to adjust the lens aperture on the camera to compensate. The guide number varies with the film speed, being

Below: a highly efficient electronic flash unit for amateur use, the Vivitar 283. It features computer light measuring for accurate exposure and has a head which can be tilted for bounced flash.

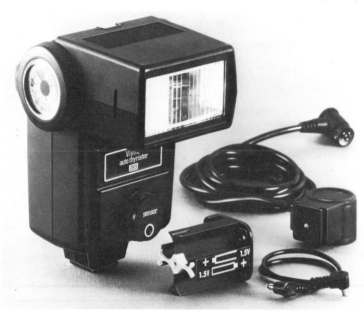

Right: the top diagram shows the operation of a flash unit of conventional design. A fixed quantity of light is delivered to the subject and reflected back to the lens. The lower diagram shows the operation of computer flash. A light-sensitive cell built into the flash unit itself measures the light being reflected back from the subject, and switches the unit off when exactly the right quantity has been delivered.

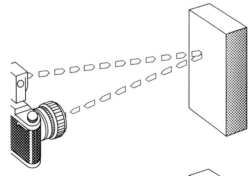

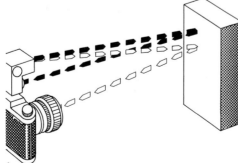

Many of the little 110 pocket cameras on the market today are fitted with built-in flash. Although such units have certain limitations, they do make it possible to use this type of camera practically anywhere, at any time.

higher when a fast film (one with a high ASA rating) is used. To work out the correct lens aperture, you divide the guide number by the distance (in metres) of the subject from the camera. A guide number of 40 would indicate that with a subject 10 metres away you need a lens aperture of f/4, because 40 ÷ 10 = 4; a subject only 5 metres away would require a lens aperture of f/8—for 40 ÷ 5 = 8. A faster film might step up the guide number to, say, 80. Then the subject at 10 metres would require a lens aperture of f/8; that at 5 metres an aperture of f/16.

The only adjustments you need to make to the camera when using flash are to focus (set the distance) and to open or close the lens aperture. The shutter speed should remain at the recommended setting—1/60 second with 35mm SLR cameras—for all flash pictures. The reason for this is that at that speed there is a synchronizing arrangement which triggers off the flash only when the shutter is fully open. Shutter and flash unit are synchronized either through a lead on the flash unit which plugs into an X-synch socket on the camera, or through a metal contact between camera and flash unit in the accessory shoe of the camera— a system known as 'hot shoe'.

Bulb flash and flash cubes work in a different way, and some cameras have a separate flash socket to accommodate these as the synchronization is different too. In this case the bulb must be fired just before the shutter is fully open, to allow the light to reach its peak of power.

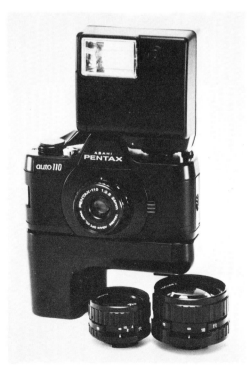

Far left: some flash units are truly pocket-sized. They are ideal for carrying with you to light up details.

Left: when you buy a flash unit make sure either that it can be used off the camera, or that the flash tube is as close as possible to the lens, to avoid hard shadows. The positioning of this unit, on the tiny Asahi Pentax 110 SLR, is an example of the second option—there will be no harsh shadows outlining the subject.

Is flash necessary?

If there is absolutely no other source of light then flash is, of course, necessary for picture-taking. But flash has a drawback which makes it a little tricky for the photographer seeking artistic effects other than in a studio. This is that the light spreads out from a relatively small source and does not bounce around and diffuse like natural daylight: the shadows it casts therefore tend to be very harsh, and very distracting, spoiling compositional effects and bringing an unnatural look. This drawback can be overcome by a simple technique called bounced flash.

Virtually all cameras have an accessory shoe on the top—a little plate with guide rails on it, into which a flash gun slides. Unfortunately, that is the worst possible position for a flash gun, for it provides no modelling shadows; since it is too close to the subject-to-lens axis it will merely put a hard shadow around your subject—especially if the subject is close to a background. And if the flash is particularly close to the lens (as it will be if you have a very tiny camera and a pocket-sized flash unit) then you may well get 'red-eye', an effect which causes portrait subjects to exhibit bright red

eyes and have the appearance of a devil! It is caused by the flash light rays entering the eyes and being reflected back from the retina, which is red. The best solution is to buy a unit which can be used off the camera, and to buy a flash extension lead which will allow it to be used one or two metres away from the camera. Red-eye will also be avoided if you do not have portrait subjects looking directly at you, although this is a less satisfactory solution since the picture will lack the personal involvement which is so appealing in pictures of people.

With the flash fixed to your camera by a longish extension lead you can hold it away to one side of you, and up high, so that the shadows it casts will much more nearly simulate those cast by natural sunlight. You will also be free to use the very effective technique known as bounced flash.

Bounced flash means just what it says: the flash unit is pointed at some large surface such as the wall or ceiling, so that its rays bounce off and spread around, thus avoiding the hard shadows of direct flash. This can be demonstrated with a torch: shine the torch directly on

If a photograph has to be taken of a subject in a confined space, such as a baby in his pram, natural light may simply not be strong enough and artificial lighting can be extremely difficult to arrange. The baby below was photographed using the bounced flash technique. You may need to practise this a little, but bounced flash, properly used, can give excellent results—notice the natural colours (flash light resembles daylight) and the lack of hard shadows.

34

someone's face in a room with all the lights switched off, and see how harsh the shadows are; then point the torch at the ceiling or wall and see how soft the light is now on the face. Move the torch around and observe which light effects are the most pleasing, and then you can use your flash unit in the same way. You will also notice how much dimmer bounced torch light is. Since bounced flash is similarly weaker than direct flash you will need a larger lens aperture. Work this out according to the guide number system by measuring the distance *from flash to reflecting surface to subject*—that is, the total distance the light rays will travel—and then open up the lens aperture by a further two stops to allow for light absorbed by the ceiling or wall.

If you use bounced flash with a computer unit you need a different technique, for the light-measuring cell of the computer flash must point at the subject (otherwise it would simply measure the light bouncing off the wall or ceiling). For that reason many computer units have swivelling heads, which allows them to be tilted up towards the ceiling or sideways towards a wall while the cell remains pointing at the subject.

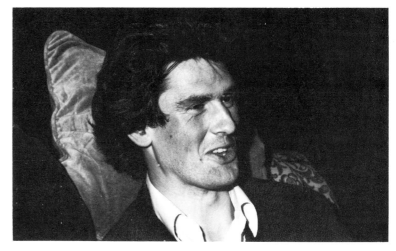

Above: electronic flash used as the sole light source—the shadows are hard, the contrasts marked.

Left: flash can be used to supplement daylight—its use is certainly not limited to night-time photography. Mounted on the side of the camera, it has added soft shadows to this little girl's face and highlights to her hair.

Below: a powerful flash unit is needed to illuminate large areas such as reasonably sized rooms.

Wedding photographs

There are two ways of photographing a wedding. One is to shoot the more or less standard range of 'set up' pictures, and the other is to shoot a series of candid scenes and portraits. The candids will make very good supporting material where a hired professional has been shooting the accepted formal series.

Before you begin any wedding photography you should find out whether photography is permitted inside the church or registry office, whether you will be able to take pictures during the ceremony and whether or not flash is permitted. The following instructions apply where nothing is prohibited.

The first of your formal pictures should be of the bride arriving. Picture her getting out of the car, or entering the church. For the latter you will probably have to use flash, as you will be shooting from inside the church porch, and there is a danger that the bride and her attendant would otherwise be in silhouette. If possible get a picture of the couple at the altar. Do that by moving to the back of the church and resting your camera on a pew, or even on the floor, in the aisle. You must certainly get a picture of the pair coming down the aisle after the ceremony; prefocus your camera for that one (prefocusing is explained on pages 44-45).

Outside the church it is time for the formal group pictures. First some of the happy pair—and take them kissing, as well as looking at the camera. You should get one of the bride with bridesmaids, and one of the best man congratulating the groom. It is usual to shoot the pictures of the ladies in full length, to show off their dresses, but you can go in close for the groom and best man shaking hands. Next, the immediate families, and then the larger group—of all the guests. Either flash or natural light will be fine for the close-up shots, but you will have to be quite a way back for the larger groups, so make sure your flash is powerful enough if you have to use one.

At the reception there is one picture you must take—the bride and groom toasting each other. You could also get a close up of the bride's hand, showing off her ring.

Candid shooting is much more free,

All the pictures reproduced here are by top society wedding photographer Tom Hustler.

Centre: a beautiful silhouette shot of the bride—exposure was selected to retain some shadow detail, but to make the dress glow with light.

Below: a must—a picture of bride and groom cutting the cake.

Below right: shoot from inside the church porch for your pictures of the bride arriving.

Opposite page, top: keep an eye on young bridesmaids and pages—they will provide many charming studies which are very welcome in candid coverage, even alongside the more formal pictures.

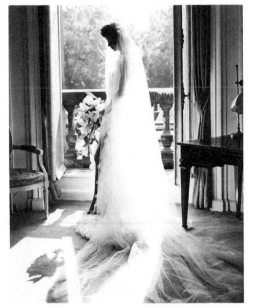

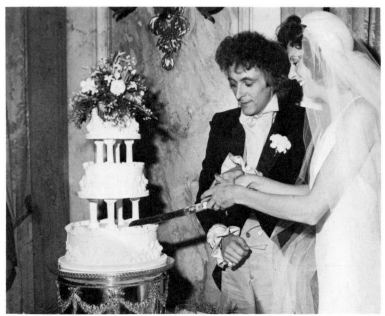

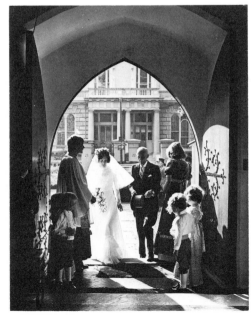

although you should still aim for the major moments—coming down the aisle, the pair toasting each other, and so on. But here you can also include all sorts of other things going on around and about. The best bet is to use a small camera loaded with fast film, and to work without flash. Look for tiny bridesmaids and pageboys suppressing a yawn, or pulling faces at each other, and be ready to shoot quickly when the bride tosses away her bouquet. Watch for the offbeat pictures—when the mums dab wet eyes with a handkerchief, and when the nervous groom sneaks a look at his watch.

Film is less able to record a wide range of contrast than is the eye—and the delicate white lace or embroidery of a dress might very easily be lost, coming out as a plain white blob in

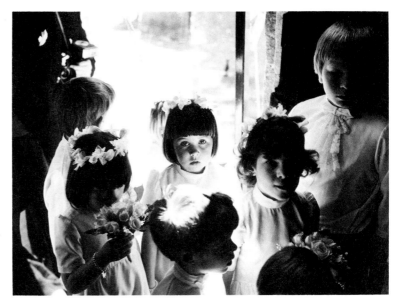

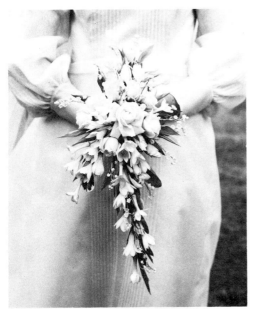

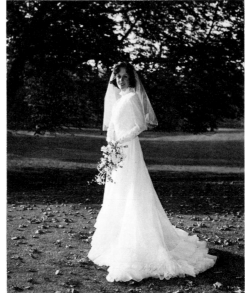

Far left: take plenty of detail pictures—bride's bouquet, new ring, bride and groom toasting each other, a close-up of the wedding cake.

Left: It is important to retain detail in the bride's dress. Fill-in flash was used here to lower the contrast and allow the texture to show.

Below: a great deal of the skill in wedding photography is in arranging the groups and in attending to small but important details—such as making sure the bride's dress is not obscured by her bridesmaids.

your pictures. For that reason avoid shooting in very bright sunlight: use a small flashgun to lower contrast, or take your pictures in gentle shade.

Whatever you do, remember that a wedding is one occasion on which you must get everything right first time; you just cannot go back and ask your friends or relatives to go through the whole performance again because you made a mistake. Practise the techniques you will want to use, and have a trial film developed to see what sort of results you are getting. Then, on the day, do not skimp on film. It would be terribly disappointing if you took just one exposure of the happy couple toasting each other only to find that one or other is in the middle of blinking. You should always shoot at least two of each scene, as an insurance policy.

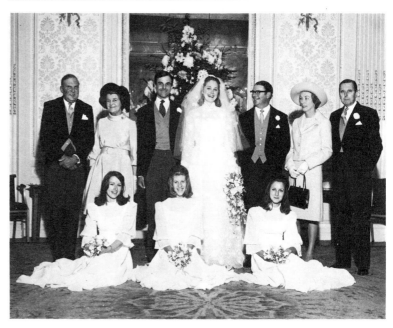

What is shutter speed?

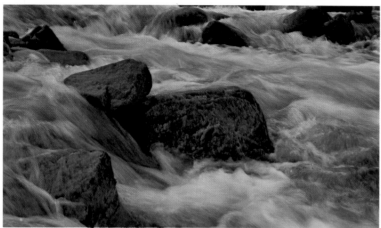

Until recently all cameras conformed to an international standard, according to which cameras with adjustable shutters were so regulated that their shutter opened for a logical series of times. Apart from a B setting, which allowed the photographer to keep the shutter open for a as long as the shutter-release was kept depressed, they had times of 1 second, 1/2 second, 1/4, 1/8, 1/15, 1/30, 1/60, 1/125, 1/250, 1/500, and often 1/1000 second. In this sequence each shutter time is half as long as the one before.

But progress is progress, and the electronic shutter is now common. Having no mechani-

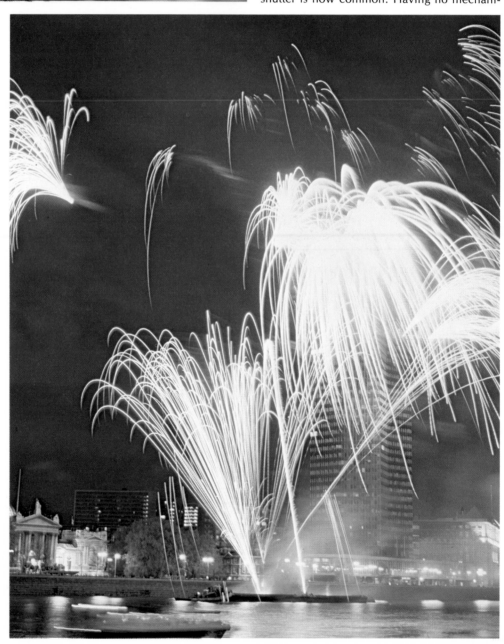

Above: a slow shutter speed has allowed the water of this fast-flowing stream to blur into an attractive smoothness. The slower the shutter the more smooth the effect.

Right: spectacular firework photos can be taken using a time exposure—one of perhaps twenty seconds. Moving sparks will appear on the film as solid lines of colour, and several fireworks going off one after the other can be recorded on the same photograph. Use a tripod and a cable release for tricks of this kind, with the shutter on the B setting.

Opposite page, top: the effect of the wind on a field of mustard has been captured by the use of a shutter speed which is neither too slow nor too fast. Without a degree of blur the composition would have been static and uninteresting; too much and it would have been an unidentifiable wash of colour.

Bottom: blurred streaks and lines in the background suggest motion, although this is an unusual application of the panning technique—since both subject and photographer were sitting on the roundabout. In fact, that made the picture easier to take, since they were stationary in relation to each other and there was therefore no need to swing the camera. The result is undeniably effective.

cal linkage, the electronic shutter does not have to be arranged so as to open in regular steps for fixed fractions of a second: it opens automatically for whatever the correct period of time is, up to several minutes. Thus it may open for a period of, say 1/47 second if that is the precise requirement—previously the user would have had to choose either 1/30 or 1/60 second.

Shutter speed performs another function: it regulates the amount of blur which appears in photographs of moving objects. A racing car moving along the track at around 100 miles per hour will travel something like fifty metres in one second. And if your shutter opens for 1/60 second the car will move forward nearly a metre during that time. That degree of movement is enough to blur car, driver, and lettering and numbering on the car out of all recognition. Of course, you could swing your camera with the car (panning) to keep the car stationary in your viewfinder: then the background would be blurred—and this is what many sports photographers do to produce an impression of speed.

Compare this with an exposure of only 1/1000 second. In that time the 100 mph car will have travelled as little as 4 centimetres (1½ in): there will be much less blur there if your camera has been held steady, and probably none at all if you have panned.

Unintentional blur is ruinous. But intentional blur is often used to produce special effects. For example, in the case of the racing car already mentioned, you could use a high shutter speed to eliminate blur, and the result would be a photograph in which the movement of the car would be frozen—motionless and unnatural.

Not everything moves at 100 mph of course, nor does everything remain still. Between these two extremes are people walking, cyclists, athletes, birds flying, animals running, water flowing, clouds drifting—and so on. Subjects such as flowing water and drifting clouds can make very beautiful effects when photographed with a very slow shutter speed— simply because we do not naturally associate them with enough speed to cause blur. Clouds hurrying fast across the sky can blur into a beautiful surrealistic effect when photographed by time exposure.

But if you make one adjustment you must always make another to compensate: correct exposure is the product of amount (controlled by lens aperture) multiplied by length of time (controlled by shutter speed). This relationship is discussed in greater detail on pages 43-44.

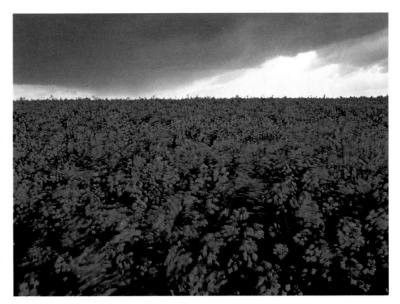

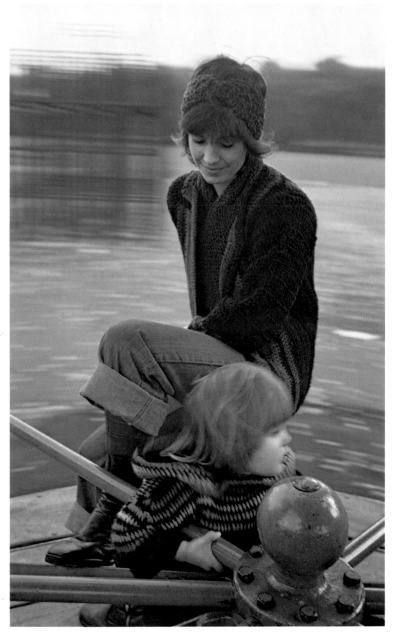

What is lens aperture?

A lens has two important measurements which immediately tell an experienced photographer quite a lot about it. The first is its focal length; the second is its maximum aperture.

The focal length describes the distance between the lens and the film when focused on the horizon, or 'infinity' in photographic language. A 35mm compact camera will have a lens of about 40mm focal length; a single lens reflex will have one of 50mm. The longer the focal length of a lens the bigger the image it will produce on a film. A 100mm lens will produce an image twice as big as a 50mm lens; a 200mm lens will produce an image twice as big again and so on. Focal length is important to the next quality of your lens—its maximum aperture.

The maximum aperture is simply the widest opening your lens can make available for light to pass through. Both focal length and lens aperture are engraved on the front of a lens: for example, 50mm and f/2. That will tell the photographer that the aperture in his lens is 25mm across—for f/2 simply means focal length divided by two and $50 \div 2 = 25$. The lens aperture, like the shutter speed control, has other functions, but its most important one is to control the amount of light passing through it. It is therefore necessary that the aperture can be made smaller, to limit the light passing through it when required (in bright light, or when the shutter speed is slowed for some special effect). The lens aperture is reduced by a series of blades, called the lens diaphragm, which slide inwards in a series of steps, each step being marked by (usually) a click stop—known simply as a lens f/stop. When the blades have slid inwards sufficiently to reduce the diameter of the aperture to 12·5mm the f/stop will be f/4 (for $50 \div 12 \cdot 5 = 4$), and it will be f/8 when that opening is reduced to only 6·25mm across.

But intervals from f/2 to f/4 and then f/8 are rather large: they are too large to provide close control of the amount of light. So lenses have a sequence of f/stops which runs f/1·4, f/2, f/2·8, f/4, f/5·6, f/8, f/11, f/16 and possibly

The pictures on these pages were taken in widely differing lighting conditions, yet they all display approximately the same range of tones. The countryside scenes below and below right were taken in the dim light of early morning. The use of a wide aperture and a slowish shutter speed made this possible.

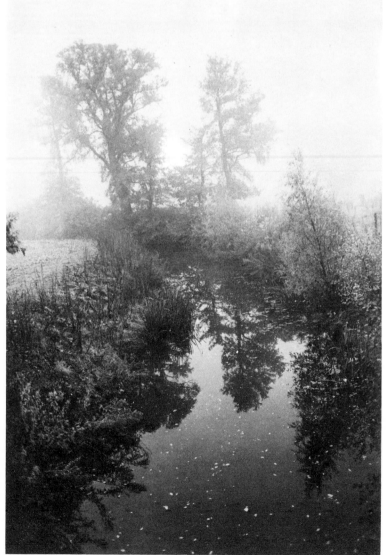

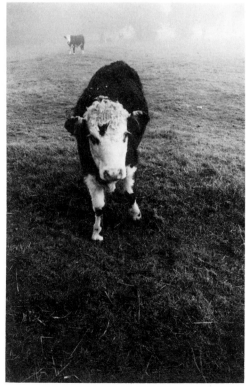

f/22. Very simple cameras may not have variable lens stops at all—and these will usually have the lens aperture fixed at f/8 or f/11. And some lenses may begin at f/2, or f/2·8.

The size of the aperture in this sequence is halved with each successively higher f/stop on the scale: a stop of f/4 lets half as much light through as f/2·8; f/5·6 half as much as f/4, and so on.

A large lens aperture will be an advantage in two special circumstances. First it will help you to take pictures in low light levels without having to use too slow a shutter speed; secondly, it will enable you to select very fast shutter speeds when taking action photographs.

But there is a limit to how large the maximum aperture of the lens can be. The biggest in general use for 35mm SLR cameras is f/1·2. The weakest part of a lens—in terms of its quality—is always at the edges. A larger aperture means more of the area of the glass will have to be used; and to polish the curved outer edges of the lens to a sufficiently high degree of accuracy is a very costly business. Quite small increases in maximum lens aperture, say from f/1·8 to f/1·2, result in a disproportionately large increase in cost.

On the other hand, the most accurately focusing part of a lens is its central area. By the time you have stopped the lens down to f/5·6 or f/8 you will not be using the outer edges of the glass, and are assured of a sharp picture.

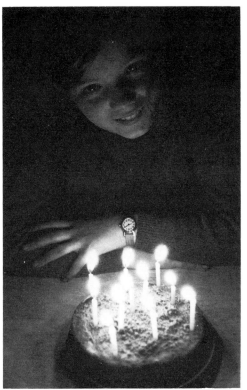

Above and far left: two pictures taken in brilliant sunshine with the lens aperture stopped right down. If a camera with a non-adjustable lens were used to take pictures in such conditions they could appear pale and washed out.

Left: the use of a very wide lens aperture makes it possible to take pictures of certain subjects in extremely poor light—even candlelight. Note that it is essential to focus on the child's eyes, because at wide apertures depth of field is restricted: the front of the cake is clearly out of focus.

Shutter and lens aperture—they work together

If your camera has adjustable lens apertures and shutter speeds there will usually be more than one 'correct' combination of the two in normal lighting conditions—so why choose one rather than another? Sometimes there will be little in it, but sometimes there will be a great deal. The pictures on these pages could all have been taken with various different settings and still been correctly exposed—but in each case the particular combination used was chosen for a good reason.

Right: taken from a moving train, with a small aperture and slow shutter speed, ensuring sharp focus over a large distance and a degree of blur to suggest speed. It would have been pointless to 'freeze' the motion by using a fast shutter speed.

Far right: the same combination of small aperture and slow shutter speed—but for an entirely different purpose. Here the photographer's priority was to get the whole picture as sharp as possible, from the mudguard in the foreground to the distant cars reflected in it. This meant the smallest aperture possible had to be chosen—and since there was nothing moving in the picture the shutter speed was of no importance. (It is also worth noting that when you take a picture of a reflection, you should focus on the reflected image, not on the surface it is reflected in.)

Both shutter speeds and lens f/stops are so arranged that changing them by one setting either doubles or halves the amount of light going through. So, if you have established that a certain scene requires an exposure of, say, 1/60 second at f/8, it is an easy matter to compensate if you decide to change one of those settings. Perhaps the scene involves fast action and you would like to use a fast shutter speed: a change to 1/125 second halves the exposure time—but if you also open up by one stop to f/5·6 you will double the amount of light reaching your film and the exposure will remain correct. Faster still? Change the shutter speed to 1/250 second, again halving the light, and open the lens to f/4, doubling the light once more to compensate. Speed up to 1/500 second—open up to f/2·8; and go faster still to 1/1000 second and opening up to f/2 keeps things balanced.

All these changes do affect the final picture, but in a way which is, fortunately, predictable. The changing shutter speed will control how much blur shows in moving subjects. The changing lens aperture affects blur too—only here the blur is caused by parts of the scene becoming out of focus.

Fortunately, photography is all about making positive advantages out of what appear to be negative effects. So the out-of-focus effect—the blur—caused in certain parts of the scene when using a large aperture can be turned to positive advantage: it can be used to blur backgrounds which would otherwise be too fussy, an effect which is especially attractive behind portraits. Details of how to do this are given in the section on depth of field on pages 60-61.

While it is theoretically true that the picture a lens produces will be sharper as the lens aperture is progressively stopped down, that does not hold good in practice. Any reasonable quality modern lens should reach its maximum degree of sharpness at around f/4 or f/5·6. Beyond that there is no advantage in stopping down, except to compensate for a slower shutter speed, to combat very bright light, or to increase the depth of field.

Sharpness depends on two things: lens aperture and distance focused on. But it is important to realize that a reasonable quality lens should provide an acceptably sharp picture of the main subject at all apertures, even its widest (otherwise that maximum aperture is merely there as a selling point, and is of no practical value).

Focusing is simple, and any camera which has a focusing lens will have some means of indicating when your subject is in focus. There may simply be a distance scale on the body of

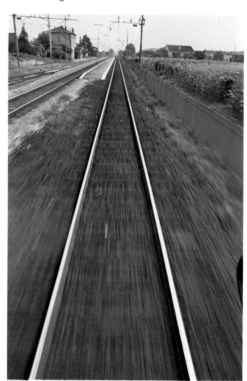
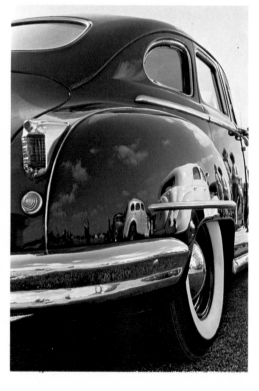

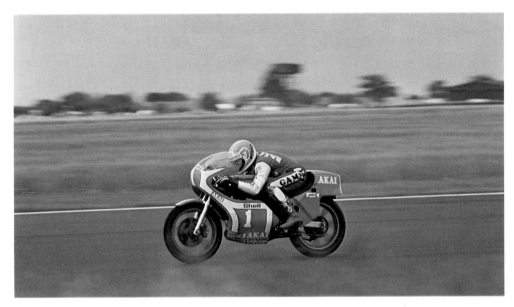

Left: a slow shutter speed is essential for a good panning shot—but not too slow, or camera shake might blur the fast-moving subject as well as the background. The aperture selected makes little difference as long as the camera is correctly focused.

the lens. There may be a rangefinder, which splits the image in your viewfinder in two until it is focused correctly, when the two bits come together to make a complete image; or there may be a piece of ground glass or an engraved screen in the viewfinder in which the image appears fuzzy until it is correctly focused, when it appears sharp. But sharpness is progressive. In front of and beyond the object focused on are zones in which everything else becomes less sharp the further away it is from the object. The lens aperture is a useful control in extending or limiting the area in which other objects in the picture will be in focus. That is also explained in the section on depth of field.

Above: the most suitable combination here was one of fairly fast shutter speed and moderately wide aperture. This ensured that a suden movement on the part of the parrot would not ruin the picture; at the same time the background is less distracting for being rendered out of focus.

Left: it was more important to prevent movement spoiling the picture than to use a small aperture—the camera angle has ensured that there is no foreground near enough to be out of focus. Therefore the photographer chose the combination offering the fastest shutter speed.

Action—how to capture it

Below: two racing shots, but there is a subtle difference. The motorcyclist is clearly leaning towards the camera, and this enhances the impression of high-speed cornering. Cars are much less likely to lean over on corners, but by tilting the camera as you pan you can artificially introduce something of the same effect. Careful cropping in the darkroom is another way of achieving the same result.

The unique thing about photography—as opposed to other methods of illustrating—is that it snatches a fraction of a second out of time and 'freezes' it. That may not appear significant if all you ever photograph is buildings, or people sitting looking at the camera. For those things do not move much, and one fraction of a second seems much like the next. But take a picture of an athlete leaping through the air and you will have on film something that happens too fast for the eye to see. And often you might find that what you have photographed appears rather ungainly, perhaps even unreal, because it is frozen. Since action is movement you need to put back into your picture the sense of motion that your camera has removed.

Panning is particularly effective with subjects which normally move at high speed, like racing cars and motorcycles—for they look distinctly unexciting if both car and background are so sharp as to make them appear to be standing still. Successful panning requires a relatively slow shutter speed and a smooth action when swinging the camera to keep the subject in the viewfinder. Too slow a shutter speed could cause the main subject to be blurred if your swing is not smooth enough. Use 1/125 second to start with, and move down to 1/60 second when you have perfected the swing. You can heighten the effect if you leave a bit more space in front of the car than behind it.

Panning is not so effective when a moving object is approaching you diagonally, and is impossible if your subject is moving head-on towards you. Here you can introduce some feeling of motion by slightly tilting the picture: a car up on two wheels or a motorcyclist leaning into a corner are certainly in motion, and a slightly tilted photograph will introduce something of these impressions.

Focusing on a fast-moving object is not easy. But the problem can be solved by prefocusing. To do this you focus on some area over which you know your subject will pass—a mark on a motor circuit, say, or a hurdle on an athletics track. Then, without moving the focus setting, pick up your subject in the viewfinder some distance before it reaches the chosen spot; as it approaches pan the camera, keeping the subject in the same place in the

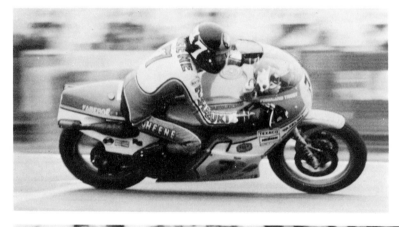

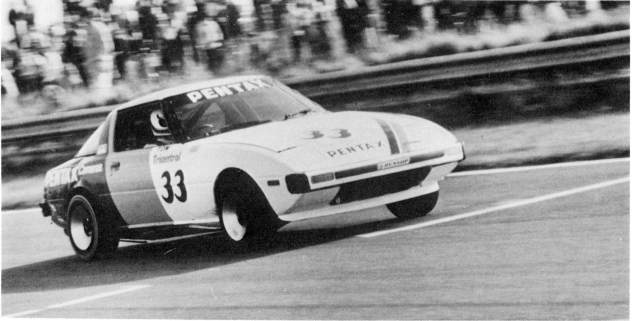

viewfinder, and take up a gentle pressure on the shutter release. Just as the subject is about to pass over your focus mark squeeze the shutter button firmly and carry on swinging. The follow through is important to maintain smoothness.

Not all action is lateral: some subjects move anywhere but directly across your line of vision. High-jumpers, pole vaulters, gymnasts, high divers can all provide as much action and excitement as a formula one racing car. Two things will help you here: anticipation, and cause and effect.

Firstly, anticipation. There is a peak in all action. The high jumper aims to stop rising and to start rolling over and down when he is just clear of the bar: that is the peak—and you need to anticipate it. Practise watching in your viewfinder until the jumper is nearly at the top, keeping gentle but firm pressure on the shutter button, and only then squeeze firmly.

Now for cause and effect: when a long jumper hits the sandpit he will send up a spray of sand, and his muscles will bulge under the impact: those obvious signs are suggestive enough of violent motion to make a good action photograph. Flying hair is another effective telltale sign of action. Even a picture of boxers frozen motionless by high speed flash will look full of action if one of them has just landed a punch, causing his opponent's head to jar, face to squash, hair to fly. So watch your chosen action before you start to shoot, and look for those moments when motion—the cause—creates the effect which tells of that motion.

Left; the high jumper is so obviously in motion that there is no need to resort to tricks. However, it is important to catch the peak of the action, and to do this you will need to anticipate it.

Below: when action is continuous and there are no definite peaks, it nevertheless pays to anticipate the most interesting moment. The two swimmers passing each other make a more interesting composition than either one alone.

Left: the long jumper has been frozen in time at the moment of landing. But far from destroying the drama of the action, the spray of sand and the athlete's knotted muscles and outstretched arms tell the story as graphically as any amount of blur or other trickery.

Films: you must choose

Never just go out and buy a film—always choose it carefully. Your first choice will be: colour or black and white?

Why bother with black and white when the whole world is coloured anyway? As explained in the section on composition (pages 24-27), colour film and black and white require different approaches. Black and white is still much used by enthusiasts who like the artistic effects it can produce. The essence of black and white photography is in pictures which stand or fall by design alone, not because of pretty colours. But the choice is very much a personal one.

You will be offered black and white film for black and white prints, colour negative film for colour prints, or colour reversal film which produces transparencies (slides) but which is increasingly being used to make high quality colour prints also. Each has its own particular advantages.

In the snapshot market colour negative film is hugely popular. Developments over the past few years have made colour negative film as sensitive as black and white film, and so it can be used in any lighting conditions. The film is easy to use, too.

All colour films are prone to turning out results which differ in colour accuracy from the original scene. But the film processing industry is now equipped with automatic printers which can correct quite large 'colour drifts' in a negative and produce a print which is perfectly acceptable. The popularity of colour prints has brought fierce competition for the massive processing business, and colour prints are quite inexpensive, at least in the enprint size (an enprint being slightly smaller than postcard-size). It is a very easy matter to have bigger enlargements made from colour negatives.

Colour reversal is the film for transparencies (slides) and is the film most used by professionals and by keen hobbyists. It is quite simple to make colour prints from transparencies, although the process is very much slower than making black and white prints from black and white negatives.

Because the chemical processing of reversal film produces the transparency in a single step there is no opportunity to correct colour drifts. So the possibility of colour being wrongly rendered must be guarded against when shooting.

The varying colour temperatures of different light sources have been explained on pages 14-15, and you will be aware that tungsten light (ordinary house bulbs) will produce a red cast on film designed for use in daylight. One solution is to use a special filter to correct the colour, but this will absorb some of the light and will have the effect of making your film less sensitive. This method is useful if you want to take one or two pictures indoors while your

Artificial light such as that produced by ordinary electric bulbs (not fluorescent tubes) in the home is quite different from daylight—try switching on a table lamp at midday and you will see how yellow it is. The human brain adapts to these different conditions, seeing them both as normal. But film cannot adapt, so you need to use special film in tungsten lighting.

Right: both types of light are present in this picture. It was taken on Kodachrome daylight film, so the light from the lamp on the right looks unnaturally yellow, although in fact all the colours are accurately recorded.

camera is loaded with daylight film. But the best solution is to use one of the films specially made for tungsten lighting, as they do not require the use of filters. Such films would give a very bluish result if used in daylight or with electronic flash (which is very similar to daylight in colour temperature).

Colour film is less well able to handle contrast than is black and white film. So you should avoid taking certain types of picture in very bright sunlight which creates harsh shadows. The harshness may not matter so much in landscape views or any other distance view, but it certainly will matter in close-ups and portraits.

Colour reversal film requires very accurate exposure—it is said to have little 'latitude'. If the correct exposure for a scene is 1/125 second at f/8, with black and white film you could overexpose by up to three f/stops (using f/2·8) or underexpose by up to two f/stops (using f/16) and still get a more or less acceptable print. A colour reversal film would not tolerate that. One f/stop either side of f/8 would be the limit: overexposure, particularly, ruins transparencies—giving them a thin, washed-out look. A degree of underexposure may often make colours stronger—it increases saturation—but overdoing this makes the transparency dense and useless.

More can be done, and more easily, to adjust the final image on the print when shooting in black and white. That is why many photographers consider it more creative than colour—it allows scope for more personal expression in the end result.

The four pictures on this page show a scene in daylight and one in artificial light, each taken once with the right kind of film and once with the wrong kind.

Top: daylight film used for a daylight scene.

Above: the same scene taken with film balanced for tungsten light.

Far left: daylight film used in tungsten lighting.

Left: the same scene looking much more natural, taken on film balanced for tungsten lighting.

The speed of film: does it matter?

The speed—the sensitivity to light, the ASA rating—of a film matters a great deal. ASA values, like lens apertures and shutter speeds, progress in a logical fashion. The slowest film generally available is rated at 20 ASA; 40 ASA film is twice as fast, and 80 ASA is twice as fast as 40 ASA and four times as fast as 20 ASA. The popular 400 ASA film is twenty times as fast as 20 ASA.

As already explained, both shutter speeds and lens apertures progress by doubling or halving the exposure. Film speed ratings fit the same pattern. So, if a scene requires an exposure of 1/30 second at f/8 on a film of 200 ASA, then on 400 ASA film the same scene would require only 1/60 second at f/8—or 1/30 second at f/11. Thus, by making a careful choice of film speed you can introduce great flexibility into your photography—tailoring it exactly to your needs for action shooting, low light shooting, even street scenes at night.

There is a physical change in films of different speeds. This has to do with what is known as grain. Broadly, slow films produce fine grain and fast films produce coarse grain but there are many stages in between.

'Grain' consists of the clumps of black metallic silver which make up the negative image: these would appear under a powerful magnifying glass as an irregular pattern of black shapes (coloured shapes in colour film). But remember that a negative has to be enlarged, and a transparency projected to a

Above: for extra-fine detail a very slow film is needed. However, this does limit the choice of subject, since a relatively long exposure is required.

Right: landscape taken on 400 ASA film. This type of film is popular among landscape photographers, since it is adaptable for low light situations and can handle fairly high contrast, as here.

large size, and this enlargement will make the grain pattern more evident to the naked eye. In fine grain films the clumps are small, in coarse grain films they are large. Linked with the size of the clumps is the capacity of the film to record detail.

Do not worry too much about grain, however; the important thing to remember is that if you want maximum detail you will need a slowish film. But landscape subjects and much portraiture, in which there is no great need for masses of detail, will be perfectly all right on fast film: indeed, many landscape photographers always use fast film, for it gives them the ability to work in low light, and to photograph fascinating effects at twilight or early dawn. But note that grain, if it appears at all on an enlargement, shows particularly on plain areas—and it can make skin look very mottled. Very fast films should not be used if you are going to make huge enlargements of portraits.

There is another quality, besides grain, affected by the ASA rating of a film. That is its ability to cope with high contrast—to record detail in both brightly lit and shadowed areas of the subject. The rule is a general one, but here it is: slow films, especially very slow films of less than 100 ASA, tend not to be able to hold detail in both light and dark parts of brightly lit scenes, but films of 400 ASA and faster are able to do so as long as the contrast is not outrageous. The films in between, of 125 or 200 ASA, are good all-purpose materials, making a valuable compromise between ability to record much detail and their ability to cope with contrast.

Above: satisfactory photos can be taken even by the light of a single candle. There will be some loss of detail with very fast film, but that may not matter.

Left: the faster the film the more evident the grain structure tends to be, an effect which is magnified when negatives are greatly enlarged. If you do not object to graininess you can take action shots in extremely dim light by using ultra-fast film.

Transparencies

In general the transparency shows colour with greater brilliance and accuracy than the colour print. Even so the overall colour balance varies between different makes. The flower (right) and the racing car (below right) are on Kodachrome. For the boat at sunset (below) the photographer preferred Ektachrome, which, being somewhat cool in its colour reproduction, helps to counteract the low colour temperature of the light at this time of day.

A transparency consists of three layers of emulsion, sensitive to blue, green and red. The exact degrees of sensitivity of each layer, and the relationships of the layers to each other, vary between films from different manufacturers—just as coffee, cigarettes, washing powder and any other product varies between brands. This means that different brands of colour film will record the same scene in different ways: one might be especially good at recording reds (which are always difficult) while another excels in its handling of blues and greens; yet another may seem the finest to you for recording skin tones the way you prefer them. One brand may produce an overall warm effect, while another reproduces colour in a rather cool fashion. These differences can be an advantage—offering you yet another way to control your photography by selecting the brand you know will give you a particular atmosphere.

Of all the ways of producing a photographic image the transparency requires most skill at the initial stages. For what goes on to the film is what you show, whereas prints can be changed in emphasis, in tonal value, even in shape—by cropping, as well as by various techniques at the printing stage. It is not impossible to crop a colour transparency by masking off pieces with black tape, but it is not particularly satisfactory, since you reduce the image area available for projection, and the masking is so often untidy. It is important therefore to compose your picture accurately at the time of shooting. Get in close, too, so that the picture area is filled with the important subject matter. This is not difficult to do with experience.

It is in the handling of contrast that you must exercise particular care with all colour film.

Left: in any kind of colour photography the most faithful reproduction is obtained when the light is not too harsh and contrasty.

Below: where marked contrast is involved the transparency is capable of holding more detail than the print, although this is still much less than the human eye can encompass.

Outdoors, on a bright day, the pupils of the eyes adjust automatically so that you can see detail in the brightest scenes. If you then switch your attention to something in deep shadow, or go indoors to a dimly lit interior, the pupils of the eye will open up to compensate, so that you still see detail perfectly clearly. Film does not make any such adjustment, so if there are both light and dark areas in the same picture some detail is obviously going to be lost.

But how much detail will be lost? Transparencies can record detail over a constant ratio of very much less than the eye can perceive—and prints record an even lesser ratio than transparencies. So, on a glaringly bright day a great deal of detail will be lost if the scene you are photographing contains large areas of both brightness and darkness. Avoid that in one of the following ways: use a flash unit to throw light into the shadows; avoid either excessive brightness or shadows altogether, or take your pictures when the sun is weak or hazy.

When using colour reversal film especially you should decide whether to shoot for the shadows or the highlights—you must decide where lies the detail you particularly want to record. Take your photograph so that there is a preponderance of either highlight or shadow, then there will not be huge areas devoid of anything interesting.

Black and white prints

What makes black and white photography so flexible is that much control is possible at every stage of the process from unexposed film to finished print. It is also possible to make black and white transparencies quite easily—either by using special black and white reversal film, or by contact printing (or re-photographing) monochrome negatives to produce a positive image.

Between original scene and negative the photographer can introduce many variables. First he can select the ASA rating of his film for a special effect e.g. no obtrusive grain, or much detail in low light; then he can alter the tone of things before his camera by putting a filter over the lens—he can cut out glare from water and glass, he can make the sky darker, make dark-toned flowers appear white, cut through distance haze; finally in developing the film he can make it higher or lower in contrast, more or less abundant in evident grain. And that is only to get to the negative.

Ansel Adams, the famous American land-scape photographer, has said that a black and white negative is a bit like a musical score—it can be 'interpreted' in so many different ways. The man who prints his own black and white pictures has an array of choices before him. He must first decide how large his pictures will be, and enthusiastic photographers regard the 40·6 × 50·8cm (16 × 20 inch) print as the best size for hanging on a wall. The next decision will be how much of the image on the negative is to be printed and how much cropped away. At this stage the composition of a photograph may be greatly improved, simply by cropping unnecessary or distracting elements, concentrating on trimming the important shapes into a pleasing balance. Besides cropping, the photographer can darken or lighten certain areas of the print, which will also change emphasis.

Paper comes in several packs, from soft to hard, which can affect the strength of the image, and its contrast; and in addition the development time of many papers can be changed to alter further the contrast of the image. There are several paper surfaces too, from smooth and glossy to delicate matt. And some paper gives a brownish-tinged black, while others lean towards a blue-black.

All photographs fade eventually, but black and white pictures can be made what is known as archivally permanent, and given a very long life, by special treatment. For that reason, museums and private collections of art photography tend to favour the monochrome print.

The huge growth in popularity of colour enprints—and the consequent highly competitive processing prices—has brought about a curious position, in that it is just about as expensive to have black and white materials

Black and white photography allows enormous flexibility and great scope for self-expression. For this reason many artist-photographers make it their choice. In the suburban scene below, the dull red buildings and dirty doors of various colours would detract from the lonely central figure if they were shown in colour.

A striking and unusual landscape which relies on the bold, almost abstract shapes of land and trees mirrored in the water for its effect. You can prove this by looking at the picture upside-down: the composition loses none of its impact.

commercially processed as it is to have colour materials done. The sections on home processing will indicate how simple it is to do the work yourself though—and how much more enjoyable. However, if you do have your black and white work done by your local dealer or specialist processor, you would be well advised to have contact prints made in the first instance. These are tiny prints, the same size as the negatives, but (except in the case of 110 format film) it is easy enough to examine them through a magnifying glass: having done so you can then choose only the satisfactory ones to have enlarged.

Black and white photographs are very much easier to retouch, or 'spot', than colour pictures. You can remove blemishes, even wrinkles under someone's eyes, by using a very sharp blade to scrape them away, and you can obliterate little specks by scraping away any dark ones and painting over light ones with a very fine paintbrush. Special retouching kits are sold for these purposes, which include black inks with a suitable blue or brown tinge, to match your paper. The most widely used paper is known as bromide, which is supposed to give you a neutral black, but there are variations between the brands produced by different manufacturers.

Above: strong lines and harsh contrasts convey the drama and fierce competitiveness of the motor racing world.

Below and below left: two prints made from the same negative, showing how cropping can improve the composition. The tree trunk on the far left was included by accident; cropping it during enlargement restored the intended balance of the photograph.

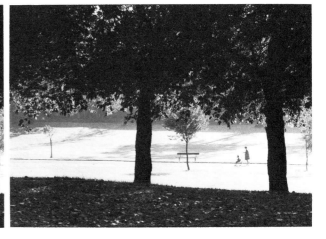

Colour prints

Colour prints are the most popular product in the snapshot market. The colour enprint has become spectacularly popular largely because of the huge sales of cameras which produce tiny negatives—the simple little 110 and 126 cameras. Here the performance is adequate for enlarging to enprint size. But from 35mm or 6cm (2¼in) square negatives it is possible to get colour prints of great tonal beauty and con-taining an incredible amount of detail, even at the imposing size of 40·6 × 50·8cm (16 × 20 inches).

The colour print is a more flexible way of showing your photographs than the colour transparency, although it cannot display the same range of brightness. But a colour print can be altered in tone, as it is printed through filters: thus, displeasing colour bias can easily be removed from a negative.

Colour prints come with different paper surfaces, as do black and white prints. Glossy paper tends to make a picture look brighter (it reflects light very readily) and sharper, and suits very lively subjects—action, or children playing. Matt paper softens colours, and does not show detail quite so well as glossy. But it is particularly suitable for portraits and for deli-cate landscapes. Matt paper is also easier to retouch than glossy.

Perhaps surprisingly, hand-toning of a black and white photograph, to give a very delicate colour image, remains popular: it was much in vogue at the turn of the century, when post-cards would often be made that way. The effect can certainly be very pleasing, and gives a vintage air—especially when the original is treated to give it a sepia (brown) effect.

Instant photography cameras for the amateur market are almost exclusively designed to produce colour prints: some seventy percent of instant film packs on the market are of colour print material. At present, instant photography

Colour prints can be made from transparencies, but the print cannot possibly look exactly the same as the original as it encompasses a smaller range of brightness. However, it does give the photographer an opportunity to alter the colour bias if he wishes. Here, the original was felt to be rather too warm, so some of the orange-red colouring has been filtered out.

Colour prints can be transferred on to a canvas background and framed for hanging on the wall. However, textured canvas or paper destroys fine detail—choose a glossy paper where it is important to keep maximum sharpness.

for the amateur market does not produce colour prints with as much detail as does conventional photography.

The bright colours of the instant prints are quite accurate when flash is used, but remember that there is no correction of colour drifts during processing as with conventional photographs.

Increasingly, colour prints are being made direct from transparencies, as well as by the more usual negative/positive process. There are two ways of doing this: by copying the transparency on to colour negative material to make an internegative, from which the finished print is then made; or by printing the transparency directly onto colour reversal paper. Transparencies chosen for this treatment must be relatively low in contrast, as the paper cannot handle a great range of brightness. The results are very beautiful when suitable transparencies are used.

If you do decide that you would like to have some of your colour prints enlarged and displayed on the wall, buy a spray can of the special material to provide a coating on the print for protection against fading.

Far left: prints from transparencies can be made either by rephotographing the original to make a colour internegative, or directly on to colour reversal paper. Where bright colours are involved colour reversal paper, such as Cibachrome, can be especially effective.

Left: matt paper is especially suitable for quiet, restful scenes such as landscapes and most kinds of portrait.

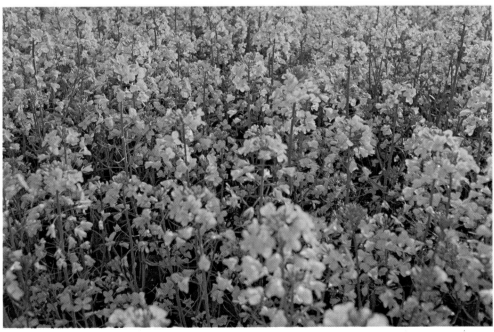

Be on the look-out for subjects which will make interesting or unusual prints for the wall—as this field of massed flowers, with its almost abstract appearance.

Views on the grand scale

Landscape has always been a favourite subject for painters, who have been inspired by the interesting shapes of the countryside, and by beautiful lighting effects. Photography makes a more accurate record than even the most detailed painting, and has proved itself especially suitable for landscapes.

Landscape is a wide subject, and can be undertaken with superb results from virtually any camera and any kind of film. The most important requirements are a good sense of composition—preferably an eye for simple but harmonious shapes—or an appreciation of how to recognize delicate and subtle contrasts of colour.

The biggest common mistake in landscape photography is to assume that the camera will see the same as the eye sees. Always remember that it does not. It is a 'one-eyed' instrument, and can only *suggest* distance and scale, which your two-eyed vision perceives very easily. The camera photographs whatever is in front of it within a relatively narrow angle of view—it does not move its vision from side to side, as the human eye can, to take in a whole range of mountains, the wide sweep of a river, or the horizon-to-horizon stretch of an open plain. And without a little help the film in your camera may not be able to record delicate sky detail.

First, it is important to identify what you want your picture to show. There will always be something predominant, even if only a beautiful cloud pattern above open countryside; or at least there will be some outstanding impression—perhaps of remoteness, of blue distance, or snow-capped peaks. Your task will be to make that predominant factor or impression show clearly in your photograph. A landscape photo which is nothing more than a distant view, with an undistinguished sky and nothing of real interest for the viewer to focus his attention on, will be a flop—no matter how vivid your memories of the original scene.

Suppose it is a beautiful sky above an open plain which has interested you. Then be bold

Below: the dramatic sky is the dominant feature of this landscape; the use of a red filter intensified the effect. But clouds alone are often not enough to make a picture—notice how the taller grasses in the foreground add depth to the composition.

Right: the fascinating interplay of light and shade transform an ordinary scene into a vivid urban landscape with criss-crossing diagonal lines. The sunlit walls lead the eye towards the top right corner, the shadowed walls away towards the top left. Placing the horizon high in the picture has added to the feeling of tension.

and make the sky important in the picture, arranging your composition so that the horizon is very low down with the sky taking up a good deal of space. If you can adjust your camera then stop down one f/stop beyond the apparently correct exposure: that will help make the sky stronger, the horizon darker. If shooting in black and white use a yellow filter, or even an orange one (more dramatic) to darken the blue of the sky while throwing any clouds into greater relief. And when using colour a polarizing filter will have a similar effect.

Landscape is most often successful when there are bold shapes within the picture area. Mountains or hills looming beyond a lake will almost automatically make a pleasing result: but do not compose it so that the hilltop or peak is dead centre: that would be too symmetrical. An off-centre placing of the peak, giving a diagonal sweep down across the picture, is much more pleasing.

Trees, old stone dykes and churchyard monuments will all provide bold shapes for the foreground of landscape pictures. Keep them slightly dark in tone—almost in silhouette, and they will greatly aid the sense of distance and scale.

Generally speaking, it is best to avoid having people in your landscape pictures—for they will attract a great deal of attention to the detriment of the rest of the scene. However, just now and again you may find that the inclusion of a person suggests the scale of the scene.

Top: the sloping angles of tree and road make a curious balance around the pivotal point of the dead tree between them.

Above: an altogether more peaceful landscape. The picture is divided into broad horizontal bands, each of which has its own texture. Try to remain constantly vigilant when you go out with your camera—it is all too easy to miss photographs like this through simply not noticing the potential hidden in the scenery.

Left: bold foreground shapes lend scale, giving a graphic quality to an otherwise rather nondescript sort of subject.

An all-round view: panoramas

Every town and city, every beautiful location, has its high spot. There is nearly always somewhere you can go to get a 'panoramic view'. Such places are so prized they are even marked on tourist maps. It is a perfectly easy matter to make a photograph which gives an all-round view—which takes in *all* the scenery around you in a 360-degree sweep (or less, of course, if you wish).

Easy—but it needs a little care. Even so a panorama can be made with any camera.

A panorama is really a very wide-angle view. But it differs greatly from a view made by a very wide-angle lens. For the wide-angle lens takes in a wide angle of view in all directions—upwards and downwards, as well as from side to side. If you took a very wide-angle view of a range of mountains you would get a tiny strip of mountain scenery in the middle of your picture, and a great deal of sky and foreground: your subject, the mountain range, would be small—and lost. A good panorama is made up of pictures which show the main subject good and big and detailed.

To begin with, the simplest panorama consists of two pictures overlapping to provide a larger than usual view, thus including more of a scene. The ideal is a scene in which there is no foreground detail, for the relationship between foreground and middleground always changes a little as you move your camera.

First, take one picture, keeping your camera perfectly upright, so that the film is perpendicular to the ground, or parallel to any walls or pillars or trees in your picture. Next, swing your camera across the scene until the new image in your viewfinder is overlapping the one you first saw by about one-third. That is easy enough: when you compose your first picture simply note some object about a third of the way in from the edge of your viewfinder, and swing your camera until that object is on the very edge of your viewfinder for the next picture. Then have a print made from each picture, with colour and density of tone exactly the same in each.

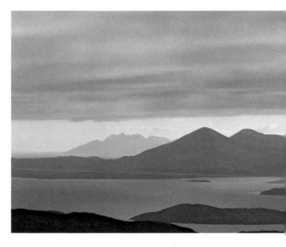

All you have to do now is trim away the overlapping parts until your two pictures butt perfectly together to give a wide view—a panorama. It is often acceptable enough to trim away the overlap by a straight cut from top to bottom of the picture, but the join may be noticeable. You can make it less so by having the cut follow the line of a road, or building or tree. To extend your panorama simply shoot more pictures in the same way.

Paris from the Montparnasse Tower. This panorama consists of seven separate transparencies of which considerable sections have been cropped away, since a good deal of overlap is necessary when streets and buildings have to be joined up. Although this was taken with a standard lens, an even better effect could be obtained with a telephoto of 135mm with 35mm frames taken vertically—less overlap would then be necessary and the subject would be on a larger scale. Fast-moving clouds have caused some problems here, but the overall impression is so spectacular that minor imperfections can be overlooked more easily than in conventional photography.

Using a standard 50mm lens on a 35mm camera you would need a dozen photos (each overlapping its neighbour by a third) to make a panorama covering a full circle around you. But there are other lens and format arrangements you may wish to experiment with as you get better at panoramas. Perspective changes, and changes of relationship of foreground to background and middleground, are the biggest difficulties you must overcome—for if evident to any great degree they make matching up without joins showing extremely difficult. Wide-angle lenses exaggerate these problems; telephoto lenses minimize them. And you can

shooting very wide panoramas, so that the degree of overlap is evenly controlled, and the camera back (or the film plane) can be made absolutely perpendicular. But you will run into an unavoidable problem if you are shooting on a bright day—variations in the colour of the sky as you swing your camera nearer the direction of the sun. Nothing can be done about that: you must either accept the steps of differing blues in your colour pictures (differing grey in your mono pictures) or wait until the sun is overcast and the sky is an even tone. But panoramas are so unusual and so obviously a 'trick' that viewers will accept changes in sky

This is a three-part panorama taken on the Scottish coast, over the Inner Sound, to Raasay and Skye. Because of the great distance to the closest mountains—about fifteen miles—very little overlap of transparencies has proved necessary. All the same two others were taken at the time, just to be on the safe side; sections of them could be used in the joins between these three if it proved necessary.

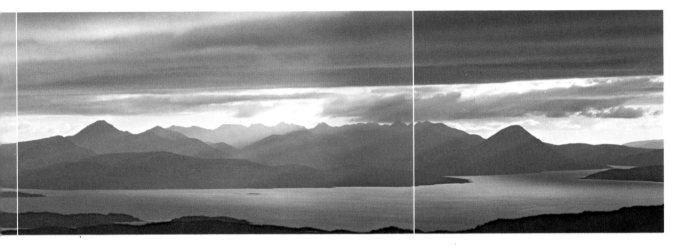

produce fine panoramas using a 135mm telephoto lens on a 35mm camera, with the camera turned on its side so that your individual segments are upright, not horizontal: much less overlap is needed (just enough to ensure the picture edges do join without missing anything of the scene), but you will need more pictures—at least thirty of them for a complete sweep.

It is always advisable to use a tripod when

tone for the sake of the panoramic interest. Avoid, like the plague, close-up subjects in panoramas. If shooting from the top of a tall building look out for safety fences, windguards flag-poles, etc. And if on the top of a mountain or high hill try not to include nearby boulders or bushes; your panorama should flow smoothly along the horizon without sudden distractions.

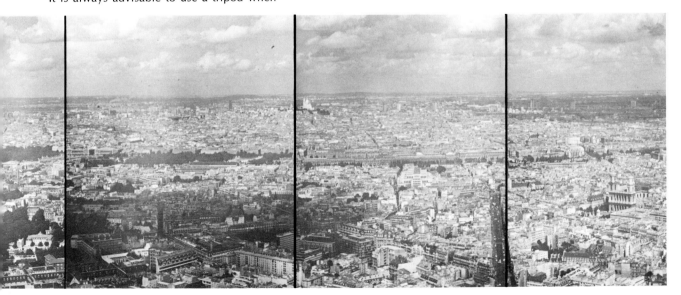

A sharp picture: depth of field

The four still-life shots on these pages illustrate the effects of differing apertures and focusing distances.

Below: the lens is focused on the nearest of the three glasses. A wide aperture (f/1·8) gives a narrow depth of field – the glass focused on is sharp, the others are fuzzy.

If you use a camera which has a focusing lens you can expect that whatever you focus on, be it portrait face, flower or whatever, will be sharp and full of detail. Even relatively cheap camera/lens combinations should give satisfying sharpness in modest enlargements. But a non-focusing (or fixed-focus) lens, as fitted on most of the 110 and 126 format cameras and some 35mm compacts, does not allow you to select an area of maximum sharpness: the non-focusing lens is designed to give an all over sharpness from a few feet away to infinity.

Why the phrase *maximum* sharpness? Because if you focus a lens on a subject, only that subject will be *really* sharp: in front of and behind it there will be zones of progressively

less sharpness. The depth of the acceptably sharp zone is referred to as depth of field – the depth of the field is variable, and can be controlled. It depends on three things: the lens aperture, the focal length of the lens, and the distance from the camera to the subject.

A camera lens is designed to refract particularly accurately the rays of light from the object focused upon: it will do that at a wide aperture, but cannot sharply record *all* of the scene in front of the camera. As it is stopped down it becomes progressively more able to do so. When stopped right down to f/16 or f/22, standard lenses and wide-angle lenses record everything sharply from a few feet away to infinity: they render great depth of field. But at wide apertures, say f/1·4, f/2, f/2·8, the standard lens renders sharp only a narrow zone across the scene: it then offers shallow depth of field.

The second factor affecting depth of field is the focal length of the lens. The rule is simple: the shorter the focal length the greater the depth of field (always assuming that the lens aperture and the distance to the subject are the same).

Third, the distance to the subject on which a lens is focused greatly affects depth of field too. But again the rule is simple: depth of field is shallowest at the closest focusing distance of the lens – which is as close as 45cm (18in) on a modern SLR with standard lens – and increases in depth the further away the subject is. The

Right: the aperture is unchanged, but this time the lens is focused on the second glass – this becomes sharp while the first and third glasses become fuzzy.

Opposite page, bottom: this picture corresponds to the second of the still-life examples – the lens was focused on the boy's face, and, since a wide aperture was chosen, objects in the background and foreground are thrown way out of focus.

Left: again the aperture remains unchanged, while the lens is focused on the furthest glass. So this glass is now in focus whereas the nearer two are not.

Below: this picture shows the effect of stopping the aperture right down to f/22—depth of field is much greater, and all three glasses are now sharply in focus. Note that depth of field extends both behind and in front of the precise spot focused on, so in a shot like this you would focus on the second glass for maximum sharpness over the greatest area.

phenomenon is spectacularly noticeable at the closest distances, but by the time a standard lens is focused on about 4·5 metres (15ft), using a lens aperture of f/8, the zone of sharpness stretches all the way to the horizon.

Whatever the factor affecting depth of field there is always a greater zone of sharpness beyond the subject than in front of it.

Focusing lenses on advanced cameras have 'data panels', which indicate the extent of depth of field at differing focusing distances and different lens apertures. These are certainly quite informative. But there is a more immediate way to check on the depth of field if your camera has a preview button. When this is pressed you will see in the viewfinder just how much of the scene is likely to be sharp in your picture.

Depth of field is a phenomenon caused by the behaviour of light rays when refracted through a lens, and the effect cannot be avoided—it is an inherent part of photography. But it can be controlled, and even turned to advantage. Considerably out-of-focus objects are blurred and soft in outline, therefore not obtrusive. And by choosing a wide aperture to throw the background out of focus you can create a soft and gentle backdrop against which your main subject will stand out very clearly—ideal for portraits. This technique is known as differential focusing, and is often used in sports photography: photographers covering sports events tend to use telephoto lenses and wide lens apertures, enabling them to select high shutter speeds; the combination of two of the factors affecting depth of field produces an exaggerated blur in the background.

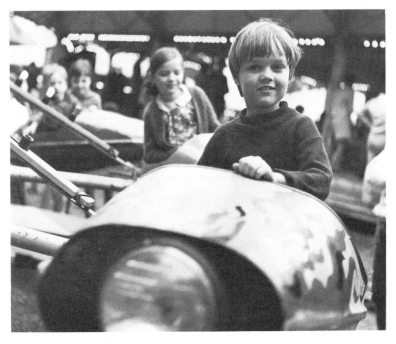

Portraits for the wall—head and shoulders

Until photography arrived only the very rich could afford portraits of their relatives and loved ones—for the painter was slow and expensive. Now even a child of ten can produce a portrait that could become a family treasure.

The essential for really close contact between viewer and portrait is that the subject's eyes should be looking directly out of the picture: you can make sure of this by asking the subject to look straight into your lens. Looking, but *not* staring. Do not, whatever you do, intimidate your portrait subjects so that they are afraid even to blink.

Since a portrait is there to be scrutinized endlessly you should discourage female sitters from wearing make-up that is too outrageous. By all means let them have the eyes lightly and naturally made-up—but thick mascara shows up terribly, as do those glittering substances used for eye-shading. The same goes for hair (men, women *and* children): not too carefully tended and controlled, but *natural*.

How much should you include in your portraits? The face is the main thing, and sometimes that is sufficient on its own—the face filling the entire picture area, even being cropped a bit. But mostly you will find it better to include the shoulders and upper torso too—leaving a bit of space around the face for a nice relaxed and airy impression.

The lighting for portraiture should be very simple. Recently it has tended to become very complicated, particularly for studio portraits, with photographers switching on more and more lights in pursuit of unusual effects. Sometimes unusual effects do work well—a spotlight behind a blonde girl's hair will give her a stunning halo, for example—but it is important to remember that every light casts a shadow. Portrait pictures which are a mass of conflicting shadows look a mess.

Particularly satisfying for the close-up portrait is natural light coming through a window.

Below: pomp and ceremony make portraiture easier—the mayor with all his official regalia makes a natural subject.

Below right: a completely plain, dark background is excellent for the more formal type of portrait. It is easy to arrange, too—an open doorway into a darkened room is all you need.

Photoflood lamps are popular too, although they are now being superseded by electronic flash. If you do use artificial light try the effect with just one light, and then with two. If you use more you will have trouble with shadows and uneven lighting. However, a third light may often be usefully employed to light the background only, when a bright setting is required. When using two lamps consider one as the main light, placing it in front of, to one side of, and slightly above your portrait sitter: use the second lamp almost twice as far away from the sitter if it is of the same light output as the first—purely to lighten the shadowed side of the face. If you do have only one lamp and want to lighten shadows you can position a white card, or even a newspaper or tea towel so that it reflects light into the shadows. As always in photography it pays to experiment, moving lamps and reflectors around until you have a pleasing effect.

The background for close-up portraits should be perfectly plain: nothing should detract from the facial expression and the eyes. If your house is full of patterned wallpapers you can arrange a plain dark background by putting your sitter in front of an open door leading into a darkened room. For a lighter background hang a white cloth such as a bed sheet behind your sitter.

Left: the face and eyes are the essential elements of a portrait—you do not always need more than that.

Below left: if your subject wears glasses take care that they do not obscure part of the eyes. You can reduce glare to some extent by using a polarizing filter, but it absorbs quite a lot of light and may necessitate a considerable increase in exposure.

Below: as a rule it is better to avoid using patterned wallpaper as a background for portraits you intend to frame; on the other hand, you may wish to portray people as you see them—in their own surroundings.

63

The full-length portrait

Below: the subject for a full-length portrait need not necessarily be standing up, although whatever pose is adopted should look comfortable and relaxed.

Below right: portrait of a country dweller. This type of picture should be of interest even to people who do not know the subject. In this case the clothes, the easy stance and the rural setting make the photo as much a portrayal of a way of life as of an individual.

A portrait should do more than please the person portrayed: if it is to be a successful picture it must have something of interest even for those people who may never have met the sitter. And that does not mean your sitter must be a beautiful girl or an Adonis—interesting design and interesting lighting are the important things. Fortunately, simplicity is the essence of the best portraiture; fine detail is only a distraction—especially in the background.

In Victorian portrait parlours there would often be an elaborate chair (and the subject always seemed to stand behind it, never sit on it), some curtains and perhaps a pedestal with a potted plant. Sometimes the background would be painted to represent a country scene or a garden. The modern professional portrait-ist frequently does use simple props also, but plain backgrounds are more popular. Take a leaf out of the professional's book and go for plain surroundings whenever you can.

The design of the picture as a whole is the important thing in full-length portraits—whereas we are concerned more with expression when making head and shoulders pictures. But the body is very expressive too: the way we sit or stand can express arrogance, tiredness, fear, merriment, relaxation—and so on. Thus, how you pose your sitter's legs and arms can have a great effect on your pictures.

Many very experienced photographers do not believe in posing their portrait subjects at all—preferring to go for what is known as the 'candid' view. That is fine provided your

subjects always stand or sit or walk in a photogenic way, but the chances are they will not. However, if you take control of the sitting, and instruct your subject what to do, you should be able to produce whatever impression you wish.

A full-length subject requires more attention to lighting than does a head and shoulders portrait, for there is more to be lit. Uneven lighting—much on the face, little on the body—can look very unreal. For that reason any lamps you use should be some way away from your subject, to spread the light evenly. But do not worry about having an equal amount of light coming from both sides of the subject. With light stronger on one side you will create interesting shadows and help the design of the picture. Such moody lighting is known as 'low-key', when a great deal of the picture is in shadow.

You must be careful to avoid distorting your full-length portrait subjects, for it will happen even more readily than when photographing just a head and shoulders. If your sitter's hands or legs are much nearer the camera than the rest of his body, they will appear grotesquely distorted in the picture. This is especially likely to occur if you use a wide-angle lens, which will encourage you to move closer to your subject. The best safeguard against distortion is to have your subject contained within one plane.

Props can sometimes be useful in full-length portraits. It would be quite in keeping for a bookish person to be sitting on a comfortable chair with a book on his or her lap. And an old man would look perfectly natural filling his pipe. But do not over-elaborate.

Remember that daylight from a large window is especially good for portraits, but bounced flash is a very good substitute and will provide a pleasing overall lighting of soft quality.

The little girl's disarming shyness, expressed in the way she stands as well as in the way she seems to want to hide her face, is emphasized by her smallness against the stable door and by her position in the lower half of the picture. But the Alice in Wonderland atmosphere belies the painstaking skill of the photographer—such pictures do not come about by chance. Having a background contained in almost the same plane as the subject meant that it could be razor-sharp. This is not a distraction, but an essential part of the portrait, particularly the lucky horseshoe above the girl's head. At the darkroom stage the print was deliberately overexposed, the effect being to distance the scene slightly, giving it a nocturnal quality.

Children: use patience

Children are probably responsible for more cameras being bought than any other single photographic subject. This is not surprising for they can make delightful picture material.

Before you begin taking photos of your children it is worth asking yourself what it is you want to show. The chances are it will be mannerisms—a particular smile, or the way the youngster is involved in playing with his toys. Having decided what it is, it would be pointless to go and change things by dressing the child up in his or her Sunday best, or by smarming down his hair to make him look tidy. Photograph children as you find them.

It is also important to remember that children are very much smaller than adults—and they will look rather distorted if you take your pictures from your own eye level. Get down to it—lie flat on your stomach on the floor; get down on your knees if your little subject is sitting on a chair.

Children, being very curious by nature, will show great interest in what you are doing, and may be constantly stretching out to touch your camera. That just might lead to an occasional very charming picture, but it will represent a distraction—something the child was not doing before. You must have patience and wait until their interest in you and your strange doings has subsided—as it certainly will, even if only for a moment or two. Many experienced child photographers like to use a long lens, something like 135mm, as this keeps them a suf-

ficient distance away from the subject to be outside his immediate territory, and thus less likely to attract interest.

Children are often so appealing that almost everything they do is photogenic. But always aim to preserve the natural look. At bath time there is often a fine chance for a natural picture, but if you have to use flash in your bathroom do try to use the bounced flash technique: babies and hard shadows just do not go well together.

Deliberately set-up pictures of children are often a disappointment. The child feels uncomfortable and fidgety, and the whole thing looks too obviously staged. But there is one set up shot that can always be recommended—that is the birthday picture, taken as the child blows out the candles on the cake. Candlelight is quite strong enough to take pictures by, although it will produce a very red effect on colour film. It is not safe to rely on an automatic exposure metering camera for candlelit shots unless you are very close to your subject—so close that face, cake and candles just about fill your viewfinder. For if you are too far away the automatic camera is likely to set to slow a shutter speed, which will cause a blurred picture. Using a film of 400 ASA you can get a perfectly good candlelit shot with an exposure of about 1/30 to 1/60 second and f/2. But make sure you focus on the child's eyes, for with a wide aperture, and at close distance, depth of field will be very limited.

The photographs on these pages are all perfectly straightforward. No special equipment was needed and no special photographic techniques were used— except that one (opposite page, right) was shot from the back of an open rabbit hutch in a menagerie. The quality they all have in common is that they are the result of waiting— sometimes for quite long periods—for the children to pose themselves naturally. It is usually worth it in the end—patience has its rewards.

Automatic exposure metering

In the early days of photography there was a great deal of guesswork and trial and error, particularly in assessment of exposure. Later photographers used devices which compared the brightness of their subject with the known brightness of a little lamp. Others used a device from which they could read off a number, the numbers becoming progressively more difficult to see as the light faded. Then for many years photo-electric meters using a selenium cell were universally accepted as the most accurate of light-measuring instruments. Sophisticated modern versions of those are still used in professional studios today.

It was a relatively easy step to build selenium cell meters into camera bodies; then they were always conveniently to hand, and the photographer simply had to transfer the meter reading on to his camera controls. Then came the cadmium sulphide cell, followed by other kinds of cell, all of them capable of measuring light more accurately than the selenium cell meters, especially at low light levels. With the new cells came an increase in the number of cameras with exposure meters built in. The user had simply to adjust the camera controls until two needles in the viewfinder coincided. That system was not automatic—the user could heed or ignore his built in metering as he chose. But before long manufacturers coupled the internal meter directly to either the shutter speed or to the lens aperture. The new breed of cameras—semi automatics—were said to be of the shutter-preferred or aperture-preferred variety, and these two systems are still widely used.

The obvious next step was to couple both lens aperture control *and* shutter speed control to the internal meter so that the camera itself made all assessments, decisions, and adjustments. Most 35mm compacts are fully programmed in this way. Single lens reflex cameras vary in the systems they use, but the vast majority now have a through-the-lens metering system. This means that only the light coming through the lens is measured; that should, in theory, lead to perfect exposures every time.

In fact the through-the-lens system does yield a very high proportion of successes, but you should study the instruction book of a new camera very carefully for clues as to how the metering system measures the subject. Some

Right: the viewfinder of the Olympus OM-2 when set for automatic exposure. When the user has selected the lens aperture the correct shutter speed is selected by the camera, and can be read off on the scale. When set on manual a simple over- and under-exposure indicator replaces the shutter speed scale.

An intriguing demonstration of what a semi-automatic camera of the aperture preferred kind will do. The photographer chose a fairly small lens aperture, giving a good depth of field, and let the camera work out the correct shutter speed for itself. This turned out to be quite slow, with the result that there is a considerable amount of blur in the foreground figures. However, the photographer was not displeased with the effect as it suggests the bustle of underground traffic.

Far left: the drawback with fully automatic cameras is that the user cannot always influence the decisions which the camera makes, and there are occasions when it would help if he could. Here, the camera has taken an average reading over the whole scene, rather than expose selectively for the face. Since the rest of the scene is on the dark side, the face, sleeves and hands are overexposed.

Left: an automatic exposure metering system which takes its reading from the centre of the image area will ignore a bright background and a dark foreground, and expose correctly for the main subject only as long as it is right in the middle of the picture—which in this case it is.

cameras simply measure all the light from the subject, while others use two or more tiny measuring cells to take a reading from different parts of the subject—such as the centre, where it is assumed the main subject interest will be.

Knowing how your camera's metering system takes its reading or readings will help you avoid disappointing results when taking pictures of usually bright or dark subjects, and when shooting under very unusual lighting conditions. For example, if you wanted to photograph an exceptionally bright subject, such as a landscape with a great deal of very bright sky, you might find that your exposure metering system has assumed that the brightness is coming from all over the scene, and it may close down the lens aperture too much, leading to under exposure. And the same thing could happen when photographing a scene which included one very bright light source—such as a spotlight.

This subject requires no depth of field, since every part of it is roughly the same distance from the camera—therefore the aperture selected will not make any difference. Since there is nothing moving in the picture the shutter speed will not matter either. And since the light and dark areas are evenly distributed over the entire image area the metering system cannot expose for the wrong part. Put all these factors together and you have an ideal situation—the exposure is guaranteed to be perfect.

Correct exposure

In a situation like this, where the range of contrast goes way beyond that which film can handle, you have to decide whether to expose for the highlights—the sunlit wall—or the shadows. Since the subject is also in the sun the choice is an obvious one. Detail in the interior of the house has had to be sacrificed. Fortunately this improves the composition.

'Correct exposure' is what you have when a photograph looks right—not too dark and dense, not washed out, pale and grey—and the details look bright and clear. But correct exposure is almost always a compromise. Films can handle only a limited range of brightness, which is why the best results are obtained in hazy lighting rather than in harsh sunlight—and it follows that if the range of brightness is very wide some parts of the photograph will be underexposed and other parts will be overexposed. As long as such areas are quite small—a door open in the distance, say, leading to a dark interior, or a glint of brilliant light from a window pane—it will not matter: the whole scene, if mostly full of detail, will still look acceptable. But there are frequent occasions when a photographer must decide whether to expose for the highlights or for the shadows. Obviously, he can only make such a decision if his camera has an adjustable lens so that he can put it into practice. But even more important, he must have an understanding of the nature of light. This is more important than the need to understand the mechanical bits of a camera.

If you understand the nature of light it is not difficult to relate to it the particular tricks of any new camera you begin to use.

The simplest adjustable camera has varying lens apertures and shutter speeds, but one or other of those may be indicated by symbols—bright sun, partly obscured sun, obscured sun, rain—instead of an actual mathematical value. Suppose the camera is set for bright sun: it would probably be set at something like f/11 and 1/125 second. But if you wanted to take a picture in the shade of a tree, you would set the camera at the symbol for dull weather and by so doing you would automatically open up the lens aperture or slow down the shutter (depending on the camera design). If the setting were left at bright sun your subject beneath the tree would not be very clear—rather murky in fact—although sunlit leaves and green grass would look fine, since you would be exposing for the highlights.

Amongst very sophisticated cameras there is a growing trend towards complete automation. but photographers sometimes want to give more or less exposure than the built-in metering system indicates, to make sure of holding detail in a particular part of a scene. Then there will often be an adjustment to allow one or two stops overexposure or underexposure. If there is not, what then? There is one standby which never fails. It is the varying ASA values of films which makes that standby available.

No matter how fully automatic a camera may be there is always one setting the user must make: he must set a dial or lever of some kind to the ASA value of the film he is using. Every adjustment in photography affects others—all the settings are inter-related. With a film of, say, 400 ASA in a fully automatic

Three examples of 'correct' exposure—technically correct, that is. For the picture on the far left the meter reading was taken from the dog only, so there is plenty of detail in his coat. The reading for the picture on the immediate left was taken from the wall only, so the whitewashed brickwork is nice and clear, but the dog is reduced to a silhouette. The centre picture is a compromise, made by averaging the two readings out. So which one is really correct? The answer is simple—whichever one you like best.

camera you can easily make the camera *over*expose by one lens stop—simply by moving the ASA setting from 400 to 200; and you can *under*expose by one stop if you move the ASA setting from 400 to 800. Thus, with all but the most basic of cameras the photographer does always have some degree of control. Even on instant cameras which are otherwise fully automatic there is a lighten/darken control.

The better you understand light the more accurately can you visualize how your finished picture will look. Severe underexposure, for instance, will cause dense black in your pictures. You might get this when photographing a cottage in sunshine with the door open: the interior will be very dark. The blackness is caused by absence, or insufficiency, of light beyond the open door. And even though your eye may perceive details inside, if nothing is bright enough to record on your film everything beyond the door will go black.

Left: if your camera has weather symbols instead of numerical values you can still use your photographic skill to avoid common errors. The setting chosen here was that for bright sun, because the subject is brightly lit even though almost the entire image area is in the shade. The rose leaves are correctly exposed, while the shady background is denser than in the original scene.

When there is even lighting from all over the scene the problem of which part to expose for does not arise. The range of contrast falls within that which film can handle, so that highlights and shadows alike are full of detail.

Handling sky effects

The sky is very important in setting mood in photographs, and how it appears can be easily varied. When you consider that it is going to appear in just about every picture you take outdoors, the importance of paying attention to it becomes evident.

The most basic variation is in how much space you give the sky in your pictures. It can dominate, taking up most of the space, with the subject just occupying the bottom of the picture. Such an approach is justified when the sky is particularly dramatic or interesting.

A great deal of sky showing in a landscape picture lends an atmosphere of peace and wilderness. But tilt your camera down so that the sky occupies just a strip at the top and there is a different effect—a kind of claustrophobia, a tension. You might use that kind of composition to make a point when photographing a crowded city, for example.

In the section on filters (see pages 84-85) you can find out how to emphasize the clouds, and how to darken the blue of the sky; but there is another technique for giving prominence to sky and cloud effects: using a wide-angle lens. This takes in a wider field of view than the standard lens. It also makes perspectives appear steeper and more dramatic. When used on a landscape with a fine, cloud-streaked sky the lens will make the sky appear vast, and the clouds will seem to explode towards you from a point a great distance away. The more wide-angle the lens the more marked the effect—and it is even more exaggerated when used with a polarizing filter and colour film, for then the sky will be a deep blue at the top, shading away to a lighter blue in the infinite distance.

In black and white photography control of the sky is even easier than in colour. By allowing more light to fall on his printing paper

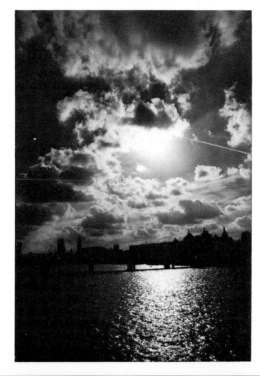

Right: it is often repeated that 'you cannot take pictures into the sun', but you can, and this is an example of the kind of result you get if you do. Violent contrasts in the sky, the horizon in stark silhouette, a glittering light path on the water, distinct rays spreading outwards from the sun—well worth breaking the rules for.

Below: taken from a car window by the author's ten-year-old son, using a camera with a non-adjustable lens. Child's play.

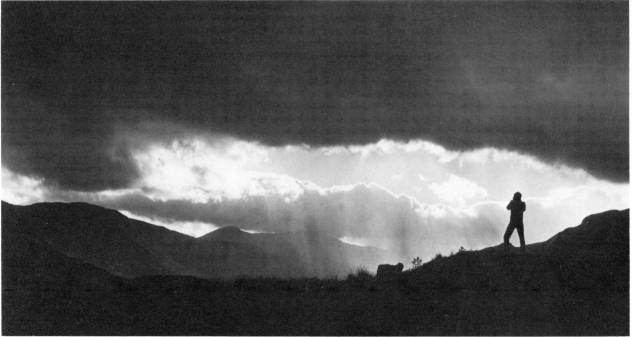

One of the quirks of black and white film is that it tends to reduce blues to an even white shade. White clouds do not stand out at all against a white background. Filters can darken the blue of the sky so that clouds show up normally; the one used for this picture was a red filter.

while making enlargements the photographer can darken the sky considerably, and can shade it from a very dense tone at the top to a lighter shade nearer the horizon. This technique is called burning in; it is very effective in the way it can enliven otherwise dull skies in pictures taken of landscapes under poor weather, and can entirely change an impression.

A colour transparency which has a featureless sky may sometimes be improved if it is bound with another transparency containing a good sky effect and nothing else. It is a good idea to make a number of interesting cloud pictures to use in this way. But always ensure that the lower part of such pictures is perfectly plain—for you do not want cloud detail showing through the landscape. And make sure that any shadows on the clouds correspond with the direction of the lighting on the landscape—otherwise you will get a very unnatural result.

To photograph the stars, whether as the subject or as a backdrop to some old building or landscape, you will need a tripod, for the shutter must be opened (on the B setting) for several minutes. As the earth rotates the tracks which the stars leave on your film will appear curved, but that can be very attractive.

A very dramatic effect can be put into your skies by including the sun in your pictures and using a very small lens aperture—f/16 or f/22. The sun will appear to sprout rays, like a star; but you may also get a certain amount of flare—and you may find your picture contains several light coloured blobs, replicas of the shape of the lens aperture. However, the effect is not necessarily unpleasant.

This photograph illustrates the use of a stormy sky as a strong element of the composition. Notice how the scrubby growths appear shiny white against the dark background of the rain clouds on the right, and dark, almost silhouetted, against the brighter areas of plain sky on the left.

Sunsets are easy

Everybody knows how satisfying it is to see a really beautiful sunset. It is satisfying to photograph one, too, and a good sunset picture is the easiest of all to take. That is because the sunset itself is a progression from light to dark, and it really does not matter very much whether your picture shows it lighter or darker than reality—whatever you do you will get that lovely glow which characterizes the end of the day. The light as the sun sets is very red because its rays have to travel through a great deal of the earth's atmosphere, and they lose much of their blue content in the process. It is that red coloration, and the pattern of lit and unlit clouds, which will make your picture.

Since the sun itself will feature in your sunset pictures it will not really matter greatly which exposure you use: the sun will record anyway, as it is so bright. The shorter your exposure is the darker the evening will appear; the longer your exposure the lighter it will appear. But if there is a common fault in sunset photography it is making the exposure *too* short; for you should try to preserve some detail in the landscape, in the clouds, and in the sea if the sun is going down over water. If you wait until you can get both sinking sun and horizon easily into your viewfinder, with a good bit of space above and below, you can be sure that there will be sufficient red light about for a really dramatic effect—which is best seen when there are some interestingly shaped clouds in the sky.

Foreground water—the sea, or a lake—will enhance the beauty of a good sunset. But in their absence look for some foreground shape which will make an interesting pattern in silhouette. A straight horizon will look a bit dull. Trees, church steeples, even signposts will all break up the horizon and add interest.

Even with 400 ASA film in your camera an automatic exposure metering system will be likely to select a fairly slow shutter speed when measuring a sunset. Guard against camera shake by finding some very solid support for your camera. A low wall will be fine, and a proper tripod even better; but you can use the roof of your car or even the ground if you do not mind stretching out on your stomach.

It is always worth taking several pictures of a

Simple but effective—water makes an ideal foreground for pictures of the setting sun.

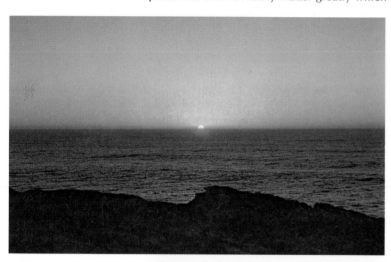

Right: the silhouette of the tree in the foreground adds interest to this picture of the sun setting behind an undulating horizon.

More a picture of the afterglow than of the sunset itself. But the sky is still extremely bright, so that it and the water are a glowing orange colour while the dry land is an impenetrable black.

sunset, at different exposures. Each one will give you a result, but they will vary in darkness, or strength of tone. This will be especially noticeable if you are shooting on colour transparency material, which will show a great range of brightness when projected on to a screen.

Remember that there *is* a huge range of contrast when the sun is going down, with the blazing globe itself enormously bright and some parts of the foreground in near blackness; for this reason all sunset pictures are compromises—they are all somewhat impressionistic. But by experimenting with different exposures you will be able to throw more emphasis on to the brightly lit clouds or on to the dimly lit landscape just as you please.

You will not need to use filters or flash or any other accessory for sunset pictures. But you should check that your lens is very clean before you begin. As the sun's rays will strike your lens directly any finger marks or thick deposits of dust and grime will be likely to cause flare. Some manufacturers have combated normal flare by producing multi-coated or super multi-coated, lenses; these have one or more coatings of material which aids the transmission of light straight through the lens and which generally helps produce brighter and crisper-looking photographs.

A blood-red, volcanic colouring gives the clouds an ominous, threatening appearance. If there is a lesson to be learned from this picture, it is that it pays to keep your camera loaded and within easy reach. Sunsets do not last long.

Close-up photography

When focused on infinity any lens is at its closest to the film in the camera. As the lens is focused on nearer objects its distance from the film must be increased – and by a progressively greater degree as the object focused on gets closer. The amount of forward movement required for very close objects is considerable, and would make lenses on focusing cameras very bulky. The forward movement is limited on relatively simple focusing cameras to cope with objects about one metre (3ft) distant. But single lens reflex cameras usually have standard lenses which will focus accurately on objects as close as 35cm (15in) or so. And some manufacturers produce macro-lenses which will produce on the film a larger than lifesize image of really small things such as insects.

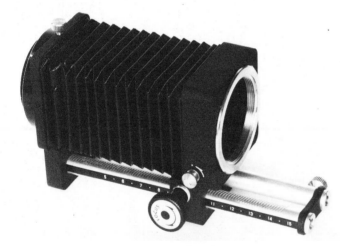

There are three accessories which alter focusing, and make it possible to go really close. These are supplementary or close-up lenses, bellows, and extension tubes.

Supplementary lenses are simply glass discs, rather like spectacle lenses, which can fit on to the front of any camera lens. They do not affect the exposure required. Weak supplementary lenses are sometimes known as portrait lenses: they can be used with very basic cameras, even vintage box cameras, to allow the photographer to get close enough for a good-sized portrait head.

Supplementaries are especially easy to use on single lens and twin lens reflex cameras, when you can see in the viewfinder whether or not the subject is in focus. But when used with other types it is necessary to measure very accurately the distance between camera and subject. When you buy a supplementary close-up lens you get with it a table which indicates how far the camera should be from the subject when the close-up lens is in place and when

Above: the hardware for close-up photography – extension tubes, which offer extension in a series of fixed steps, and a bellows unit, which is variable throughout the range allowed by its physical length.

Right: the common blue damselfly. Depth of field is drastically reduced in close-up photography, so the background is almost automatically out of focus.

the camera lens is set to various distances. It is always advisable to use a very small lens aperture when a supplementary is fitted; sharpness around the outer edges of the picture can become degraded at larger apertures. But the supplementary certainly increases the scope of simple cameras and is satisfactory for flowers and basic portraits.

Bellows are suitable only for use with single lens reflex cameras, for it is necessary to be able to see through the lens to know just what is in focus and what is not. The bellows unit—which is just like the bellows of an old-fashioned camera—fits between the camera body and the lens. By means of a rack and pinion drive it can move the lens far enough away for tiny objects to be photographed about three times larger than life. That means small objects can be shown many times larger than life when an enlarged print is made, or when a transparency is projected on to a screen.

Extension tubes work in the same fashion as bellows, but usually consist of two or three detachable tube pieces, giving a limited range of close-up focusing distances. With both tubes and bellows it is sensible to use a tripod, to keep the camera rigidly still, and to use an electronic flash unit quite close to the subject; the powerful light from the flash will help to keep exposure times short—which is absolutely necessary as the depth of field is minimal at very close distances and you will have to stop the lens aperture right down to cover even something as small as a bee or a spider.

You need not worry about backgrounds when working in ultra close-up, for the severely limited depth of field will throw anything an inch or two away completely out of focus.

Above: acorns.

Left: the common field grasshopper.

Flowers

Photographing flowers encompasses all photographic techniques from extreme close-ups to landscape views.

When photographing a large-scale view of flowers, such as a field of poppies or a patch of daffodils, take care not to lose the effect of massed flowers. It is easy to be dazzled by a glorious patch of flowers only to discover later that your picture shows a lot of empty field or a large slice of woodland glade, and just a sprinkling of flowers—a thin and sorry sight, lost amongst everything else. Get in really close, right amongst the flowers, and get down low so that the foreground blooms are large and colourful shapes. Sometimes a telephoto lens is the best bet for big patches; it has the effect of apparently reducing the distance between objects in front of the camera, and so will 'pile up' the flowers, creating a solid mass of colour—or tone and shape if you are shooting in black and white.

You may sometimes wish to include flowers as foreground in landscape pictures. This is most effective, but remember that depth of field limitations could mean that your flowers come out unsharp unless you use a very small lens aperture. With a standard lens you should be able to get a satisfactory rendition of foreground flowers as close as 30cm (1ft) or so away if you stop the lens aperture down to f/16 or f/22. But a wide-angle lens, inherently capable of retaining sharpness over a much greater range from foreground to infinity, will give foreground flowers greater crispness and make them more prominent.

Individual flower blooms can be photographed using one of the close-up techniques discussed on pages 76-77. But unless you are photographing very close you should be a little wary about the background. Avoid fussy background detail. Often a telephoto lens, used at its closest focusing distance, and with its lens aperture wide open (or nearly so) will adequately reduce depth of field, introducing a smoothly blurred backdrop for your flowers. But if that is impossible (because you have no

Below: the centre of a flower taken with a macro lens.

Below right: some flowers, especially wild ones, are very small and can easily get lost against their background. You can overcome this by getting right down among them.

78

Left: a 'flower portrait', a rather formal type of photograph which would be suitable for publication in gardening magazines.

Below: this is a weed, not a cultivated flower—but backlighting and a soft, pastel background give it a delicate beauty that you might not see in it if you found it growing in your garden.

telephoto, or other flowers are too close to the one you want to picture) do not be afraid to introduce an artificial background. Many a photographer simply puts a large piece of green or grey card behind his flower subjects, and that effectively isolates them.

Small flowers will shake a good deal even in a light breeze, and if you are photographing them in close-up their movement will be great enough to cause considerable blur in your pictures. Combat this either by waiting until the breeze drops, or by sheltering the flower. But a better way still is to use electronic flash and a very small lens aperture; wrap a hand-kerchief around the flash head and use it quite close to your flower, but take three or four shots at different flash-to-subject distances to make sure you get at least one good picture.

Photographing a flower arrangement in a vase indoors is just like any still-life photo-graphy. Make sure the background is not too fussy—a plain dark colour, green or brown, will probably look best. And make sure the arrangement is not too great in depth; you will have to take your picture from quite close, so depth of field will be fairly limited. This is a problem which cannot be solved by the use of a wide-angle lens, because the nearer flowers would then be disproportionately larger than those further away. Always use very soft light-ing—gentle window light, or bounced flash—for pictures of flower arrangements, and use low-key lighting rather than high-key.

Photographing birds and animals

The camera has now all but replaced the big game hunter's rifle and the net of the butterfly collector, and rendered unnecessary the obnoxious habit of stealing eggs from the nests of rare birds.

It is not necessary to travel to foreign shores to begin collecting photographs of birds and beasts. Our own country abounds in zoos and wildlife parks, and there are plenty of reserves where quite rare birds can be photographed.

The specialist natural history photographer will have a single lens reflex camera, and telephoto lenses up to perhaps 600mm in focal length. And long lenses will certainly be necessary in the wild, where creatures are shy and unapproachable. But an afternoon at the zoo will offer plenty of possibilities for pictures with a simple camera.

Some of the animals in our zoos are behind bars, and sometimes there is a thick glass plate between public and animals. Neither offers any problem if you can get up close; put your camera right up against glass to avoid reflections, and shoot between bars where possible. Now and again you may find it impossible to approach close enough to bars to take your picture between them. Wire mesh will frequently be even more troublesome. You can get round this to a certain extent if you have a telephoto lens with a wide lens aperture of f/2·8 or f/3·5. Such a lens will make nearby bars so much out of focus that they just do not show up on your picture at all.

In the wild the photographer does not have his subjects readily contained in one small area for him; he must seek them out. A knowledge of the habits of creatures is very valuable. However there are some habits you can teach to wild subjects. The best example is the bird table set up in your garden. If you are lucky you will find a wide variety of birds visiting it over a period of time. It is an easy matter to photograph the birds as they feed, either by using a telephoto lens from inside the house, or by setting up your camera on a tripod very close to the table and firing the shutter with a very long release—you can buy a

Below: one way of photographing birds without getting close enough to scare them away is to set up the camera on a tripod near a known visiting place such as this post, and take the picture from a safe distance by using an extra-long cable release.

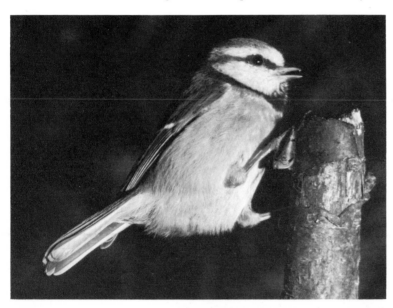

Right: a visit to the zoo will provide opportunities to photograph animals from distant lands. This photo was taken with a 135mm telephoto lens, which effectively bridges the gap made by the safety fence and pit. If these were to appear in the picture they would spoil the illusion. Be careful when taking photos in wildlife parks—always make sure your car windows are clean so that you can take photographs without winding them down.

pneumatic one which operates the camera when you squeeze an air bulb.

On a walk through the woods you may often notice a particular branch or tree stump covered in bird droppings; this is obviously a regularly visited post, and could yield an interesting picture.

Being unobtrusive is a trick to learn—you need to get quite close to small birds to get a fair-sized image—say, to within 4 or 5 metres (12 or 15ft), even with a 300mm lens. If you are brightly dressed, or constantly restless and talking, there is a good chance you will scare off the birds altogether.

For very small natural history subjects—butterflies, insects, tiny plants—you will need to use one of the close-up methods discussed on pages 76-77. Most of this can be done indoors, where you can arrange lighting to suit yourself. There are special collecting jars in which to carry the specimens home. Do not uproot wild flowers, though—photograph them where you find them. If you wish to be a serious collector of flower pictures it is always a good idea to take a general view, to show the location in which you find your flower, as well as a close-up view.

Home aquarium photography is quite easy. You will again need to work in close-up, but you might find it difficult to keep your tiny subjects in focus. Put a sheet of glass into the water, to form a sort of spare compartment, so that fish or water creatures are confined to a relatively narrow space—then prefocus and wait for them to swim into the zone of sharpness. Use a small electronic flash unit for lighting.

A grey squirrel, photographed by resting the camera on the ground and persuading the squirrel to come close by baiting with some peanuts sprinkled on the ground.

Above: a song thrush, taken with a 200mm telephoto lens.

Left: this hedgehog took up residence in the photographer's garden, so there were plenty of opportunities to take pictures of it. Even commonplace animals can make interesting photo subjects, and it is easy to picture them in their natural environment.

Night-time shooting

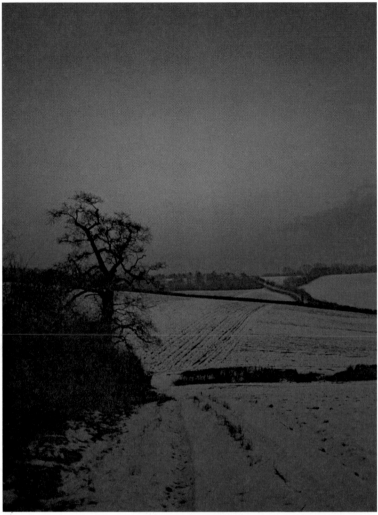

There are some truly beautiful pictures to be had long after the sun has gone down, when street lamps are alight and buildings are floodlit. But before you begin to take night-time pictures you must make sure you have some way of keeping your camera rock-steady if you want to take general views and street scenes and the like.

As a matter of fact it is really quite easy to take straightforward snapshots and even portraits outside at night, provided the light is strong enough and you have a film of 400 ASA in your camera.

When a camera shutter is firing slower than about 1/60 second the threat of camera shake is always present; and even a slight tremor of the instrument can ruin the pictures by blurring fine detail. Camera shake manifests itself in an easily recognizable way—either as a double image, or as a series of drawn out blurs which are particularly noticeable where there are points of light in the picture—street lights for example.

Using a tripod is the best way to avoid shake. Even quite a small one will be an advantage—as long as it is not too flimsy when its legs are extended. Better to have a small table tripod which you can stand on the pavement or a low wall than an extending one which wavers in the breeze.

With your tripod you should buy a long shutter release cable—and preferably one

Above: taken some time after sunset, this picture nevertheless has plenty of detail in the land. This is mainly because the light covering of snow provides a bright reflecting surface.

Right: this photo was taken by moonlight, using a time exposure of thirteen minutes. You need a tripod, and the nerve to wait around in graveyards at night, but the result is quite fascinating.

Far right: another time exposure. Although not long enough to turn night into day, it is long enough to smooth out the movement of the clouds. The thin clouds have also dispersed the moon's light, increasing its apparent size.

which is capable of locking the shutter open for long time exposures. Using a tripod not only keeps your camera steady, but it also allows you to set a small lens aperture for a picture with greater depth of field, and thus more overall sharpness. You can hold the camera in your hand, of course, but then you would need to set a high shutter speed to prevent camera shake, and that would require a large lens aperture—giving limited depth of field.

Time exposures at night bring fascinating effects all of their own. When the shutter is open for 10 seconds or so the headlights and tail lights of cars record on the film as bright streaks, brightening up otherwise dull areas of road. And rivers and fountains blur into smooth silver. If there is smoke billowing from chimneys and it is lit by town lights the effect is quite beautiful—just as it is when the shutter is open for long enough to record fast scudding clouds as smooth gradations of interesting colour or tone.

It is often a good idea to take your night-time shots before the sky has entirely darkened. Then city lights and floodlights will appear as a warm gold against a strong dark blue or violet sky.

As long as people in the street keep moving they will not show up on your night-time exposures, for they will not be in one place long enough to record on the film.

A starburst filter will turn city lights into twinkling stars, but do not overdo this, as the excessive amount of flare generated will obscure other detail.

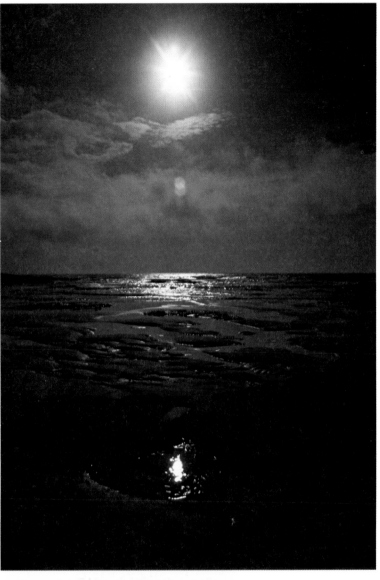

Above: this night-time scene was actually taken by day. The brightness of the sun has so upset the exposure metering system built into the camera that the rest of the picture has been converted into dense shadow.

Left: car headlights and tail lights. Set the camera on a tripod, stop down to about f/8 or f/11 and open the shutter for a time exposure—you can then record the passing of as many or as few cars as you want to, within reason.

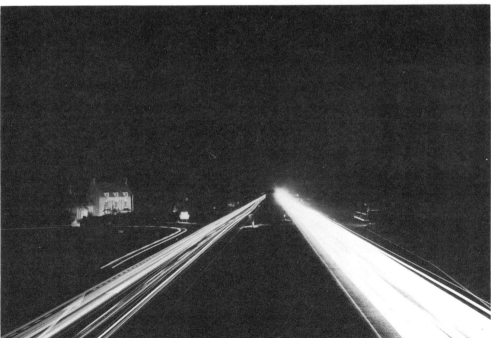

Changing things with filters

In black and white photography colours have to record in shades of grey. This they do in sufficiently different shades for us to distinguish form in a black and white picture. But sometimes the colours do play up a bit.

Notoriously bad is the blue of the sky. Monochrome film is particularly sensitive to it, and the result is that the sky will often record very densely on the negative; when printed the sky comes out flat and uninteresting—appearing as strong in white as the clouds are, so that they just do not show up at all. The basic rule of filters for altering the tones in black and white photography is that a coloured filter will cause complementary colours to *darken*, while causing colours similar to the filter to *lighten*. Thus, a yellow filter will darken blue skies just

A red rose, photographed through a red filter, appears white, because coloured filters lighten colours similar to their own. They also darken complementary colours, and so in this case the green foliage appears almost black.

a bit, an orange filter will darken the blue even more, and a red filter will make the sky appear almost black. The white clouds retain their whiteness of course, so that it is possible to control the appearance of the sky—from being sprinkled with white and fluffy clouds against grey for a summery appearance, to a dense sky with angry white clouds for a dramatic stormy effect.

A green filter will lighten green and darken red: it could therefore be used to lighten foliage while darkening red flowers—making them look more luxuriant and rich. And a red filter would lighten red flowers, while darkening foliage.

One filter alone is able to bring special qualities to both black and white and colour photography, and that is the polarizing filter. This cuts out glare—light reflected from shiny surfaces, such as glass, polished wood, water. But it also cuts out some of the brightness of the sky, and can thus be used in colour photography to darken skies. The polarizing filter, once on the camera lens, must be rotated while you examine the resulting effect for the best impression. It is therefore best when used with a reflex camera—for with any other you must estimate the effect, and that is unsatisfactory. It is a very dense filter, and needs about a threefold increase in exposure.

For making colour transparencies there are two kinds of film—one for use in daylight, and one for use in tungsten light (house lighting,

These pictures demonstrate the effect of using a starburst filter. There are various kinds available, differing in the number of rays they draw out from the light source. They can be rotated to make the arms of the star go out in any direction you like.

photofloods). It is possible to use a filter to convert each for use in the other lighting conditions. If you use daylight film indoors under artificial light, fit an 80A filter, which will introduce the blue component missing from tungsten light (but which will also necessitate a considerable increase in exposure). If the situation is reversed and you wish to use film designed for use in tungsten lighting outdoors instead (or by flash) you need an 85B filter, which adds the warmth for which tungsten film is balanced. This filter also necessitates an increase in exposure.

There are other attachments sold as filters which are not really filters at all, but which look like filters, and fit on to the camera in exactly the same way. One of these, the starburst filter, creates streaks of light radiating from any light source in your picture—sun, street lamps, headlights. Another, the prism, puts several images of the same subject on to the film. Some other attachments are similar to genuine filters, especially the graduated ones, in which there is colour (red or brown usually) on one half, gradually fading to transparent glass; such filters can be used to give a surrealist effect—say, a red sky with normal colour beneath it.

In normal conditions clouds tend to disappear on black and white film, and it needs a filter to restore them. The picture on the left was taken without a filter; that on the opposite page was taken using an orange filter. For a more dramatic effect a red filter could be chosen; for less pronounced detail a yellow one would be adequate.

The romantic look—soft focus

Soft focus does not mean out of focus, nor does it mean poor focusing because of a cheaply-made lens. What it means is the softening of the bitingly sharp detail rendered when a lens is accurately focusing on a subject.

Why should anyone want to obliterate, or at least disguise, detail? One obvious reason is to

The colour picture below was taken at the same time as the black and white print, and shows the effect of using a soft-focus attachment on a standard lens. Soft focus is not used to 'improve' portraits but to introduce a characteristically romantic look. Like any other special effect it should be used when the situation calls for it but not thrown around indiscriminately—otherwise it degenerates into a gimmick.

disguise the wrinkles on the faces of sensitive ladies. Some people might consider this a frivolous reason—though often it is one accepted by portrait studios. The fact is simply that a soft focus effect, a gentle haze, does introduce a very romantic appearance; it blots out distractions, concentrates on major shapes and shimmering highlights, and is generally very flattering.

The easiest way to produce the effect is to buy one of the specially made soft focus attachments, which look just like filters and fit on to the front of the camera lens. They are perfectly satisfactory, but they do limit you to only one degree and one style of soft focus effect—unless you buy several different ones, of course. They consist of a glass disc which has lines engraved on it; the lines may be engraved in criss-cross fashion or in concentric circles, and they may cover all of the soft focus filter or only part of it. If only part of it, the bit left without engraved lines will be the centre—the idea being that you will want a fair degree of sharpness in the centre of your photograph, with the haziness spreading around the outer edges. Such partial soft focus filters are particularly useful for close-up portraits.

It is not difficult to make your own assortment of soft focus filters. Begin by obtaining some glass blanks which will fit easily over your lens. If you cannot get hold of any then make do with UV or skylight filters. Using a mapping pen draw lines on the glass, using clear glue as the 'ink'. When the glue dries you will have a perfectly serviceable soft focus filter—and you can make as many as you wish, to give you different degrees of diffusion.

Some photographers produce a soft focus effect by smearing a trace of Vaseline on to a plain glass filter. This works particularly well when a single lens reflex camera is being used, for the effect can then be seen in the viewfinder, and the degree adjusted as required. But there are many ways of introducing the effect. Another is to shoot through a piece of cellophane, perhaps with a hole cut in the middle to provide a certain amount of sharpness.

Soft focus is essentially a light and airy effect, and for that reason it looks best on pictures taken in flat frontal lighting—dark shadows caused by strongly directional lighting are not in keeping with the mood. The hallmark of the effect, when introduced at the

camera stage rather than in the darkroom, is that the highlights tend to spread into the relatively shadowed areas. It is that which gives the halo appearance. But a certain kind of soft focus effect can be introduced during the printing stage. This 'delayed action' soft focus effect is achieved by using any of the methods described, but placing your light diffusing filter or cellophane, or even a piece cut from nylon tights, in front of the enlarger lens. The effect is then reversed, and the shadows seem to spill their heavier tone into the highlight areas.

The typical soft focus picture is rather pale and pastel looking—a charming effect. But it is best to begin with pale colours anyway, for strong colours will just look washed out and degraded. Have your subjects wear light coloured clothing, preferably white, with touches of pastel—such as a pink rose in a straw hat.

Two prints made from the same negative, the one on the far left being printed normally, that on the immediate left being printed with a fragment of nylon stocking held under the enlarger lens. The somewhat severe tones of the original have been subtly neutralized by this treatment—this is a good example of constructive use of the soft focus technique.

Below: an impression of mistiness was introduced on a perfectly clear day by breathing on the lens—a resourceful piece of improvization.

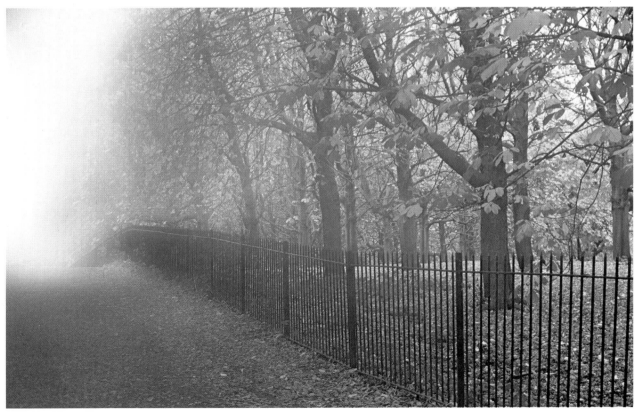

Buildings and monuments

At some stage you will probably want to photograph various buildings and fine monuments you see while on holiday in foreign cities. These are usually rather large-scale subjects, and they will introduce into photography a phenomenon known as converging verticals.

When you look up at a tall building you may not be particularly aware that it appears to taper inwards towards the top; your mind automatically makes corrections for this. But the camera makes no such corrections. It records just what its one eye sees, and those furthest parts of the building will appear smaller; the vertical sides of the building will cease to be parallel, and will converge towards the top. They will, that is, if you tilt your camera upwards to take in the whole of the building or statue.

The solution is to move back until you can get the whole of your subject into the viewfinder without tilting the camera upwards. Then every part of the building or statue or whatever will record in proper scale. However this technique will invariably produce rather a lot of foreground. The foreground can be cropped away if you are making prints. But transparencies cannot be cropped quite so readily. If the large foreground area is uninteresting to begin with you could move around looking for something to fill it. Look out for flower beds, fountains, interesting arches, and so on.

There is a special lens designed for architectural photography, called the perspective control lens; but it is rather expensive and fits only a limited range of cameras. You may find it a more suitable solution to use a telephoto lens, moving some distance away from your subject. At a distance the angle of tilt of your camera will be minimal, and verticals will record as verticals.

If you are unable to move sufficiently far back from a subject to be able to get it all in with your camera level, then you can resort to another dodge. This one is exaggeration. It produces a startling and dramatic effect in which it matters not in the least that the verticals seem to zoom away towards each other at the top of your picture. You can get the effect by not only tilting your camera upwards, but slightly sideways as well; that way the building will appear to sprawl diagonally across your picture, and the impression of its height and grandeur can be considerably strengthened.

Ornate buildings and monuments and statues should be photographed in such a way that they retain plenty of detail. For this type of subject you need shadows to throw all the detail of the architecture into bold relief. Strong lighting from one side will do the trick. The same is true of floodlit buildings. If the floodlighting is directly from the front, you would be best advised to move away to one side, where some shadows will show up.

The texture of stonework is easily lost in photography, because the film is less sensitive than the human eye. But texture can be retained to a certain degree, at least in black and white photographs, by the use of an

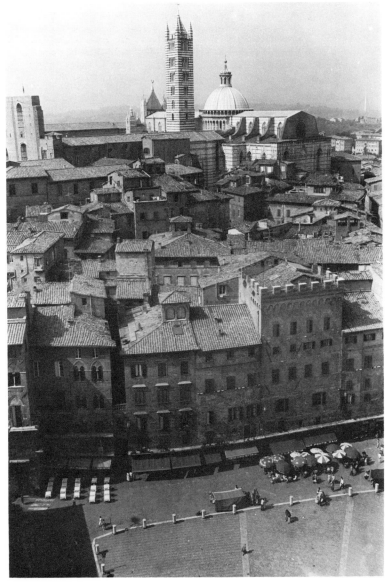

A high viewpoint creates an impression of great depth in this photograph of Sienna, Italy. Note how the perspective changes between the extremes of the picture—there is a steep drop down into the street, yet the top of the tower opposite is clearly higher than the point from which the photograph was taken.

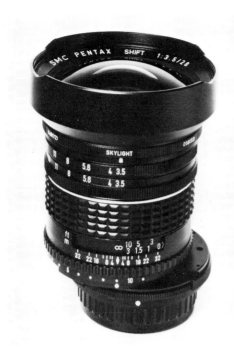

orange or yellow filter. This will also have the effect of darkening the sky behind your building, making it stand out all the more.

Sometimes you may find that your view of a building is obstructed by people continually passing to and fro between building and camera. You could wait until the view is clear, but that might take a long time. There is one dodge often used to obliterate the scurrying pedestrians, although you will need a tripod. Set your camera on the tripod, work out the correct exposure, and then adapt it in this way:

set your lens aperture to its very smallest opening—f/16 or f/22—and adjust the shutter speed accordingly. That will give you a long exposure, during which time the pedestrians will become blurred as they move. Provided there are not too many of them they simply will not appear on the film. For this to work satisfactorily the exposure needs to be several seconds—at least five. If that is not possible, perhaps because the light on the building is too bright, you can use a neutral density filter (which simply absorbs light) or a slower film.

Above left: an Asahi Pentax perspective control lens. This makes it easy to avoid converging verticals, and is much prized by architectural photographers.

Above: a yellow filter was used to enhance the texture of the stone in this interesting detail of an old bridge.

Two views of Big Ben, showing how you can overcome the problem of converging verticals by standing well back from the subject. The disadvantage of this method is that rather a lot of foreground has to be included in the picture.

Interiors

Below: the members of the orchestra have evidently moved during the long exposure; the effect is by no means unpleasant.

Below right: no such problems arise if there is no movement in the scene: the shutter can be kept open for as long as is necessary. This enables a small aperture to be used, giving great depth of field.

Most people have a hobby of one sort or another, and the camera is often an indispensable accessory, helping get the most out of other specialist interests. This is true particularly if the interest happens to be in architecture, when it might be possible to visit certain fine buildings only very rarely. The camera can readily record stained glass windows, architectural detail, and grand views inside impressive cathedrals.

Very simple cameras will need flash in dim interiors, but adjustable cameras are usually able to cope with interior lighting. However, even here a small flash unit is often a help for details tucked away in dark corners, in vaults, and at times when there is no daylight to augment the low lighting in buildings, particularly churches.

If you are going to shoot a great many interiors you should equip yourself with a single lens reflex camera, a wide-angle lens, a modest telephoto (for out of reach details), a tripod, a cable release and a flash unit with a long extension lead, allowing it to be fired away from the camera.

If you are photographing in a large building such as a cathedral you can set your camera on its tripod at the back of the building and set the shutter to B for a time exposure. With the lens aperture well stopped down and the shutter open you are free to wander around the building, firing your flash into various corners to light them up. But avoid standing between your camera and anything you are lighting in this way—otherwise you will appear in silhouette in your own pictures.

Stained glass windows display their beauty when light shines through them from outside, so do not spoil the effect by using flash. Take an exposure reading from close to the window, from the coloured segments. Some cameras allow you to lock the exposure once the reading is taken, and with these you will have no trouble when you then move back to take the picture. But automatics may not have a lock. Here you must take a close-up reading and then switch to manual, transferring the reading on to the controls yourself.

When photographing details in black and

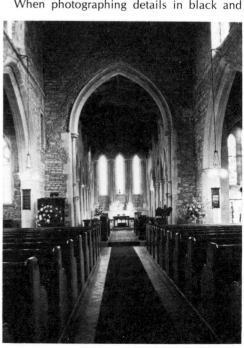

Left: using flash would have spoiled the atmosphere of this cluttered old antique shop. Ordinary tungsten lighting was used instead— you can see the reflection of the bulbs in the window at the back—and of course the camera was loaded with tungsten film.

white remember that you can enhance the texture of wood and stone by using an orange filter. Avoid harsh flash lighting when taking pictures of small detail, for the resultant shadows will be very distracting, and may even obscure some of the detail. Wrap a clean handkerchief round the flash a couple of times, and take two or three exposures to make sure you get one right.

An easy way to photograph a fine ceiling is to lay the camera on its back on the floor, making a time exposure if necessary. Again you can paint the subject with light, using your flash off the camera on a long extension lead.

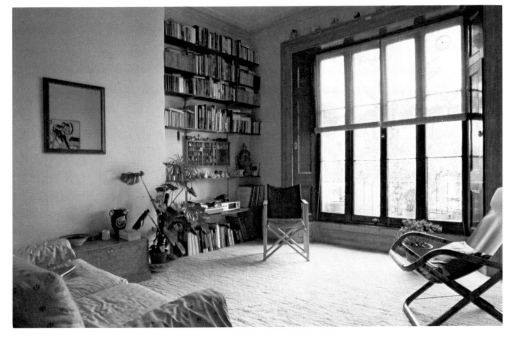

Above: an interesting angel roof in an old church, photographed by time exposure with the camera lying on its back on the floor.

Left: a wide-angle lens helps to get more into pictures of interiors such as this modern sitting room. When taking a meter reading of rooms where there is a large window, point the camera or exposure meter away from the window itself, or the picture will probably be underexposed. Remember to use daylight film for all colour photographs taken indoors by window light.

Making a sequence

If you have taken pictures at a wedding (see pages 36-37) you have already produced a story in pictures—albeit rather a stylized picture story. Still photography cannot rival moving film in recording action of course, but a series of photographs can be most informative; and the sequence may cover any period of time from a few seconds to several years. If you were to take a picture of a child each birthday you would be building up a sequence which recorded his or her progress as the years went past. And a shot of the local High Street every few months would soon become an informative document, showing how shops and buildings change.

Take a picture of your garden, or some local beauty spot, in each of the four seasons and there you have another sequence. You could also try setting up your camera in exactly the same spot every day and recording the development of a single flower, from bud to full bloom.

The first genuine sequences were made by Eadweard Muybridge late in the 19th century. He began by photographing a trotting horse, which fired a series of cameras by hitting a number of trip wires, one for each camera, stretched across the track in front of it. He went on to produce more and more sequences, which effectively analyzed human and animal motion. Today the motor drive unit used by the professional sports photographer accomplishes the same, but much more easily. The motor drive unit fits on to the base of a camera (not every model of camera has a motor drive designed for it) and advances the film very rapidly between shots, so that it is possible to shoot pictures as quickly as four exposures a second.

The motor drive is used when the photographer wants to make sure of capturing the most exciting slice of a piece of action—as when a racing car crashes, or a jumper or vaulter is flying through the air. Usually only one picture is used from the motor drive sequence of ten or twelve frames, but the whole lot can be used to tell the story of any piece of very fast or very complex action.

A sequence should be rather like a scene from a film or play; it should tell a fairly brief story—if it wanders too far the pictures are likely to lose any connection with each other. Short, simple sequences of a child at play, for example, or of a kitten playing with a ball of wool, can be quite pleasing.

It is possible to shoot extremely rapidly, even without using a motor drive attachment. The one-stroke film advance lever of a single lens reflex camera makes it possible to shoot five or six pictures in as many seconds, and

Putting on a shoe can be quite a serious business—this is evident from the little girl's unsmiling expression. When making a sequence of this sort it is always a good idea to take several more pictures than you intend eventually to use. The essential point about a sequence is that all the pictures should be linked, and should tell a story.

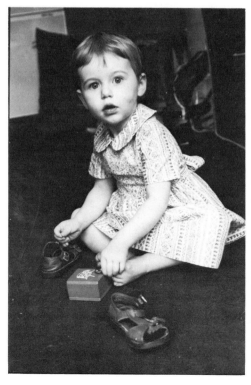 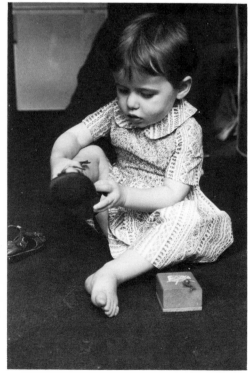

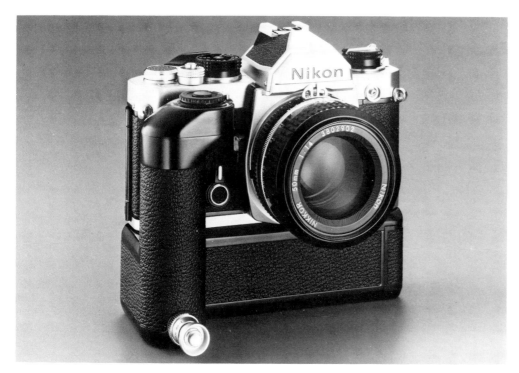

A Nikon fitted with a motor drive unit. These are quite expensive attachments to buy, but they have enabled some stunning sports and action shots to be taken. This is the fastest type of sequence; at the other end of the scale a sequence can be shot over a period of months or even years.

you can do so keeping your subject in view all the time. But it is not always necessary to shoot that quickly to make a sequence; half a dozen pictures taken while your child is building a sand castle on the beach could make a satisfying set. Nor is it necessary that you should always shoot from exactly the same viewpoint; change pace with a change of position now and then, so that you photograph your subject (especially children playing) from a different angle. But do not introduce backgrounds which are too different in tone, for they will jar and upset the unity of your sequence.

As with everything in photography it is the unusual idea which pays off and makes for the most widely interesting pictures. An excellent sequence has been made of a pregnant young woman looking out of the same window on a number of mornings at intervals throughout her pregnancy. The sequence ended with her standing beside the same window, but this time holding her new baby in her arms.

Bad weather? Don't stop . . .

Photography has moved a long way forward in a relatively short space of time, but old habits and beliefs die hard. Particularly reluctant to give up the ghost is the old idea that you need sunshine for photographs. Quite simply, you do not. You do need light, of course, but it can be *any* kind of light. And there is light even when it is raining or snowing; there is light during a thunderstorm, and there is a gentle light in the mist-laden hours before dawn.

Remember that light has both quality and measurable quantity. When it is sufficiently clouded over to produce rain or snow the sky is still spreading a quantity of light, and its quality will be dramatically different from that of sunlight. With the now common 400 ASA films there will be sufficient light for photography.

It is highly unlikely that you would want to go off on a jaunt in pouring rain just for the sake of taking pictures. It more often happens that you are stuck indoors dying to go out, but the rain prevents you; or else you are out walking, or driving, when it starts to rain. So photograph the effect of the rain—through your living room window, or even through the car window. Shots through a car windscreen are particularly effective, especially of pedestrians hurrying across a pedestrian crossing, bright umbrellas turned to pastel shades by the watery air.

A camera with automatic exposure metering will continue to give you correctly exposed pictures, even in very dull weather, but since

Above: automatic exposure metering makes a dreary day look quite normal. This delicate colour composition would become crude and garish in bright sunlight.

Right: a flash of lightning caught by time exposure.

the lighting will be so unusual it is always a good idea to 'bracket' exposures if possible. This just about guarantees at least one interesting result. Bracketing means making an additional two exposures, one at a stop more than the theoretically correct exposure, and another at one stop less. If your camera is not adjustable remember that you can introduce one lens stop difference by altering the ASA setting to half or twice as much as the ASA value of the film you are using.

Pictures in the snow can be most attractive, especially if there is some striking pattern of clouds in the sky. Again an automatic metering camera should not lull you into too much false security—the snow, being very bright, is quite likely to mislead your camera into giving too little exposure. Bracketing is most certainly worth while here. Now and again you may get some very intriguing effects by shooting while the snow or rain is actually falling; the drops or flakes, in the right lighting conditions, will cause streaks in your picture which give a most convincing impression of bad weather.

It is even possible to shoot extraordinary pictures during a lightning storm. For this your camera should have a setting (usually marked B) which allows you to keep the shutter open for as long as you wish, as you would for a time exposure. You will also need a tripod, or at least something rock steady on which you can rest the camera. Point the camera in the direction of the storm, open the shutter, wait until there is a streak of lightning (or two or three if the first one is a bit weak) and then let the shutter close. Wind on the film and try again. You should have the lens aperture set at about f/8 or f/11 for lightning shots.

Left: many people only reach for their cameras when the sun comes out, but wind and rain can provide many scenes worth recording on film. This aerial view of umbrellas queueing at the bus stop is full of whimsical humour.

Below: a fine rainbow, a uniquely bad weather phenomenon.

Left: in abnormal conditions it pays to bracket exposures (see text); in this case the photographer took several at different exposures, but chose this slightly underexposed one as capturing best the atmosphere of the day.

Building your slide collection

Slides are returned from the processing houses in neat little boxes, and these offer a good deal of protection to the rather vulnerable emulsion—which soon picks up dust and fingerprints, and is quite easily scratched. You can keep your slides in these boxes, or store them in one of the special cases which hold a hundred or so transparencies. The special slide cases usually have an index pasted on to the lid, which is a great help in quickly locating a particular picture. But you can easily construct an effective index of your own. Number your first box of slides as box 1; then the first transparency would be 1/1, the second 1/2 and so on. You could use a notebook to record the subject matter of picture 1/1 and all others. This chronological way of keeping and indexing your slides has simplicity on its side, and it keeps all the pictures from a certain holiday, or specific shooting sessions, together in your collection. But you may prefer to index and store your pictures by subject—one box for

natural history, another for landscapes, one for sport, and so on.

If you do a great deal of projecting it is probably better to store your slides in such a way that each box or container represents one slide show, and is indexed accordingly.

However you decide to store your slide collection you should attend to two important jobs as soon as the pictures come back from the processing house, First you should edit them, and then you should title them.

The best way to edit a set of slides is to use a slide sorter. This is a box with a light inside it and an opalescent top. The slides are laid out on top and shuffled around until they are in the most satisfactory order. As you sort them you should be ruthless in discarding those which show annoying faults—out of focus, under or overexposure, or which have been duplicated, or are less than pleasing for some other reason. If you leave them in you will bore all those who see them: keep only the best for showing.

A good method of filing transparencies is to arrange them into subject groups. Themes such as natural history, architecture and family snapshots are best kept separate.

Of course you may want to keep your rejects separately, for reference.

Next you need to identify and title and/or number the slides, so that you can identify the subject even years later. The best way to deal with your titling is to make notes at the time you take your pictures.

To save fiddling just before a slide show you should 'spot' the pictures. Simply stick a little piece of paper (you can buy packets of them from photo dealers) on one corner of the slide mount to indicate which way up it should be when loaded into the projector.

Some photographers prefer to remount slides in glass mounts for better protection of the delicate emulsion. It does not matter a great deal what sort of mounts you use (although paper buckles and jams a projector more easily than plastic does) but you should aim at a standardized system of mounting. Mounts of different thicknesses are a nuisance during projection, for you constantly have to alter the focusing of the lens to maintain a sharp image on the screen.

Above: methods of storing slides. Magazines and slide boxes can be clearly labelled, but for economy you could keep your transparencies in the processors' boxes.

Left: a slide sorter for the enthusiast.

Compiling an album

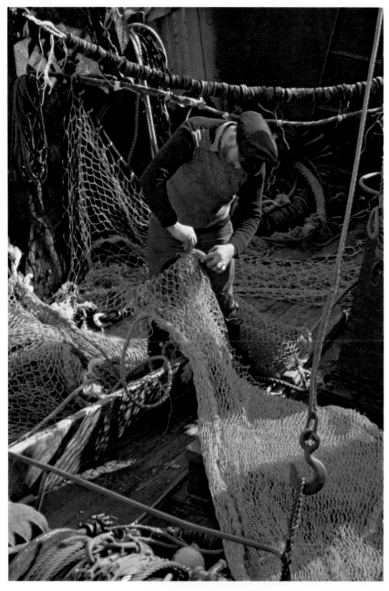

There is now something distinctly old fashioned about the photograph album which has little slots into which you slip the corners of your photographs. And in any case an interesting album should have pictures of different sizes, and differing arrangements of the pictures on its pages. It needs variety to give pace and interest. Indeed you should think of your photo album as a coffee table book—at least if you want people to be interested by it.

Buy a good big album—it is much more pleasant to leaf through one book than to fumble with a whole pile of them. The self-adhesive ones can be recommended, they make it easy for you to be imaginative in the arrangements of your pictures. It is very effective to have really big enlargements made of your very best pictures—of really beautiful views or stunning sunset shots. Give such special pictures a whole page to themselves.

An album does not have to be made up solely of photographs—especially if it deals with visits to foreign countries. You can include little maps cut from tourist brochures, perhaps local stamps, the label from a bottle of wine, restaurant menus, travel tickets—anything which will introduce flavour. You can title different sections of your album; this saves continually having to tell people where such and such a picture was taken, or who is featured in this or that snapshot.

As with transparencies, prints should be edited before being put into an album. Do not include fuzzy, dark, washed-out or otherwise unsatisfactory prints. Put in only the best.

Introduce variety by including the occa-

Pictures in an album will be more interesting if they are linked by some kind of theme rather than all jumbled up together. Unusual pictures such as these of canoes (right) and the toucan (opposite) help to bring variety to collections of holiday photos, which can otherwise get rather monotonous.

An album of your holiday photographs will be much more interesting if you include in it not only pictures of your family, but a photographic record of various local scenes and activities too. Try to get moody views as well as the usual sunny ones, and perhaps one or two shots of local industries such as fishing (opposite page).

sional sequence, or by montages and panoramas. It is easy to make an interesting montage by taking a series of shots of different parts of a building or landscape, and piecing them together on the page, rather like tiles.

There are other ways of displaying your prints than in an album of course. The boldest is to have big enlargements made and framed. Some companies offer a special enlarging service in which they put the image on to textured canvas, which can be very effective with the right subject. The treatment particularly suits subjects which are strong and rich in darkish colours. It also suits soft focus portraits, but obliterates detail and so does not really suit pictures in which the sharpness is important.

Projecting your pictures

By far the best way of viewing a colour picture is to project it onto a good quality screen in a thoroughly blacked out room. The transparency encompasses a much greater range of brightness than does even the best colour print; efficient blackout will ensure that the colours are particularly well saturated. Very light wallpaper or paint may degrade the image, through light reflected from the screen bouncing around the room. The most efficient screens are of very high reflectivity indeed, but only within a rather narrow angle; buy the very best (beaded) screen possible, and arrange for viewers to sit as near to the projector-screen axis as possible.

The simplest projector consists of a lamp and a lens in a closed box, and the transparencies must be hand-fed into it. Models with automatic slide changing and focusing make for much more comfortable viewing—for the projectionist as well as his audience. Projectors with rotary magazines allow eighty or more transparencies to be projected without interruption.

Do not make the mistake of trying to get too big a picture, for the screen will become less and less bright the further it is from the projector. About 1·2 metres (4ft) is usually an adequate image width for home viewing, as the picture will still retain its brilliance and colour saturation. For an image this size the projector needs to be about 3 metres (10ft) from the screen with an 85mm projection lens. Make sure the lens is kept free of dust and fingerprints.

Some projectors are designed to couple with a tape recorder, so that the picture is changed automatically on a pulsed signal from the tape. This allows a musical or spoken accompaniment to be played back in synchronization with the slides. If you really become enthusiastic you can buy a second slide projector. With two projectors and a special fade-in/fade-out unit you can make one picture dissolve into the next. Slide shows put on in this way can be most effective for telling a story.

You can look at your transparencies without a projector and screen, using a hand viewer. Some of these use daylight, and others have battery and bulb inside; a few are mains operated, but this limits their portability. It is convenient to use a hand viewer to arrange slides in order for projection.

Below: a set-up for the real enthusiast—two projectors coupled with a tape recorder.

Opposite page: the standard magazine will take 36 or 50 slides; the rotary magazine (below) will take 80 or so. The drawing shows how the focal length of a projector lens affects the size of the projected image at any given distance. A 50mm lens (left) will give a larger image than a 150mm lens (right) over the same projector-to-screen distance. The 50mm lens suits smaller rooms, where a 150mm lens would give a relatively small picture.

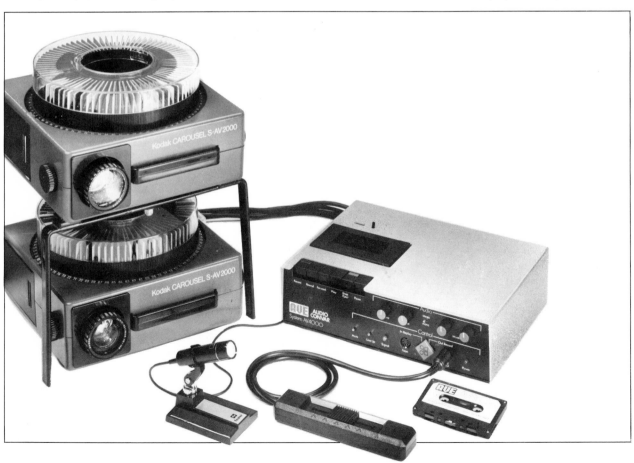

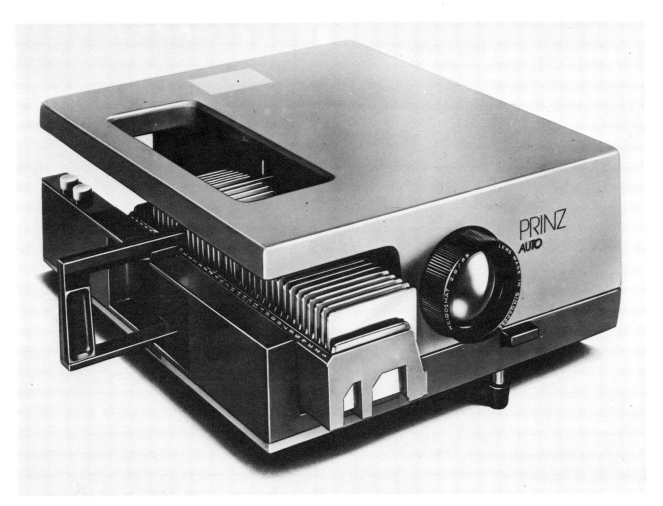

How to develop a film

To develop a black and white film you will need a developing tank, a thermometer, a beaker for measuring liquid, some developer, and some fixer, and a timer—a watch with a second hand will do. The whole process will take less than half an hour, and with the exception of loading the film into the tank it can be done in daylight or in ordinary room light. The tank has a plastic spiral inside it, into which the film is fed; after a little practice it is quite easy to do this in the dark.

There are several developers on the market, the basic difference being that some are supposed to produce especially fine grain in the negative. You can try them all out at leisure, but it is best to begin with the one recommended by the manufacturer of the film. Fixers are less varied, though the choice does include a high-speed one; this also slightly hardens the delicate emulsion of the film, and offers some protection against scratching while the film is wet and vulnerable.

Begin by making up the developing and fixing chemicals. Check the temperature—this will probably have to be 20°C. Precise instructions concerning the water and its temperature will be printed on the bottle or packet.

When everything is ready load the film into the tank in an *entirely* dark place. You should have practised this first, using a spare film, in daylight, so that you know how to feed the film into the spiral without fumbling. Screw the top of the tank on firmly. You can now continue working in a lighted room. First pour in some plain water and swirl it around the tank for a minute or two, then pour it away. This will prevent the formation of air bubbles when you pour in the developing liquid.

Now pour in the developer and begin timing; the exact length of time for which the film needs to be developed will be shown on a table which comes with the developer—usually between six and nine minutes. As soon as the developer is in the tank turn the tank upside down, and do so again at the end of every minute: this is known as inversion agitation, and ensures that the developer remains thoroughly mixed and always in contact with the film. Some tanks provide a means of agitation by a rotating spindle; it does not matter *how* you agitate as long as it is thorough.

At the end of the developing time pour away the liquid in the tank. At this stage you can pour the fixer straight in, or give the tank a quick rinse with clean water or with a special stop bath (another liquid, which has no other function than to stop speedily the action of the developer). Use stop bath if you are a slow worker, clean water if you work fairly quickly.

Once the fixer is in the tank you can leave

Right: a print made from an under-developed negative—there is no contrast, highlights and shadows being reduced to a flat grey.

Far right: print made from an over-developed negative of the same scene—the contrast is harsh and exaggerated and there is little or no grey in the shadows.

the rest to time. Fixer works in a few minutes, but provided it is not too short, the timing is not critical. When the film has been long enough in the fixer pour the fluid away, then rinse the film in running water for twenty minutes or so. This is to wash away all traces of the chemical, which would stain the negatives if allowed to remain.

When washing is complete hang the film up to dry in a dust-free place. It is a good idea to wipe off any surplus water—carefully—before hanging it up.

By adjusting the development time you can alter the ASA rating of the film, and also its contrast. As a guide, increasing the time by ten percent will double the ASA rating and increase contrast. This means that when shooting you can make adjustments, such as giving your film extra sensitivity for low light conditions, and compensate later when developing. Reducing the ASA rating by under developing is particularly valuable if you have to take pictures of very contrasty subjects; an example might be a wedding on a bright day, when you need to retain detail in white dresses as well as in the dark clothing of the men.

Colour processing, of both transparency and colour print films, takes considerably longer than black and white. The temperature at which the various solutions are used is critical. This makes colour processing something of an academic exercise which is usually best left to the commercial processing houses, where timing and temperature are carefully control-

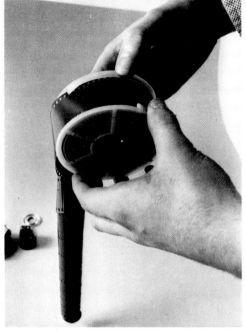

The only tricky part of the film developing process is threading the unexposed film on to the spiral spool. Use a spare film to practise this in daylight before attempting it for the first time in the dark. After a little practice you should find the operation easy enough to do in total darkness.

led and quality control is a prerequisite if film manufacturers are to allow them to process their material.

However, it is possible to uprate the ASA value of transparency film by adjusting the first development time, so very enthusiastic photographers may prefer to do their own processing, although the introduction of a number of 400 ASA films (for both slides and prints) has made it less necessary to uprate film. In any case many processing houses also offer a push-process service, and will make the uprating adjustment on request.

Far left: the print made from a correctly developed negative shows a good range of tone between dense black and pure white.

Left: the good negative itself. It is difficult to assess the quality of a negative without making a print from it.

Making a print

If you want to make black and white prints at home you will need a room—or large cupboard—which can be blacked out, for the work must be done by a special safelight. The space available should be big enough for an enlarger and three trays of at least 26 × 21cm (10 × 8in). There should also be room to store chemicals and printing paper.

Just as there are different kinds of camera, so there are different kinds of enlarger. You can begin with a very simple model, but you may later want to move on to making colour prints, in which case it makes sense to buy an enlarger which has a tray for the filters needed in colour work. An enlarger is basically a simple projector which focuses the negative image on to printing paper placed on a baseboard. The paper is light sensitive, like film, but much less so—it can thus be safely handled in the relatively weak light of a photographic safelight. The safelight should not be nearer than about 60cm (2ft) to the paper at any stage of the printing process.

Three dishes or trays will contain developer, clean water or stop bath, and fixer. These chemicals should be mixed according to the manufacturer's instructions. After fixing the paper must be washed, and this can be done in daylight or room light. Many modern papers are resin coated, and require only a few minutes washing, which can be done in a sink. But if you use bromide papers you will need to extend the washing time to about half an hour. Fixer left in the paper will stain your pictures badly.

Having chosen the negative you wish to enlarge, place it in the negative carrier of the enlarger, and move the enlarger head up and down until the image projected on the baseboard is the size you want. If you have a masking frame (a special holder for the printing paper) you can decide at this stage whether or not to crop away any part of the image.

When the image is the right size, make a test strip. Focus the image accurately with the aperture of the enlarger lens wide open, then stop down a bit. Swing the enlarger's red filter into the light path and put a strip of printing paper in place; a piece about 5cm (2in) wide will do—there is no need to use a whole sheet. Cover all but a 5cm (2in) section of it, and swing the red filter out of the way. Expose the paper for 3 seconds. Swing the red filter back in, uncover another 5cm (2in) of the paper and make another 3-second exposure. Make five separate exposures on the same strip in this way. When you have finished your paper the different sections will have been exposed for 3, 6, 9, 12, and 15 seconds. Develop it according to the instructions, rinse in water or stop bath and then fix. After a few minutes you can turn on the main room light and examine the strip. One section of the test strip will be correctly exposed, being more full of tone and detail than the others. It is easy to work out how long this section was exposed for, and that is the exposure time required for a complete print. However, if the entire test strip turns out to be underexposed, you should

Right: an enlarger and stand. The three knobs on the top are for use in making colour prints, although it would be best to leave this until you are thoroughly well acquainted with the black and white process.

Opposite page, left: a basic inexpensive enlarger. When not in use it packs away into the carrying case, which also acts as a stand. There is a filter drawer for use in colour printing.

Below: a test strip.

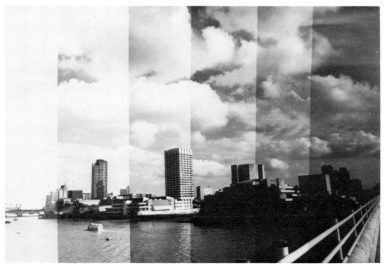

make another one, still with 3-second intervals, but this time starting at 15 seconds.

Put a whole piece of paper in the masking frame, expose it for the required time, then put the paper into the developer. Keep the liquid moving in contact with the paper surface. After the correct developing time transfer the paper into the rinsing tray for half a minute or so, swishing the liquid over its surface, and then put it into the fixer. When the fixing time has expired you can switch the lights on to examine the print. Remove the paper for washing, and after that let it dry naturally.

The process really is very easy. But it is also an operation over which you can exert a great deal of control. If, for example, the sky on your negative is too dense so that it appears pale and uninteresting on the print you can expose it for longer than the rest of the picture by

covering up all but the sky area, and giving it several more seconds. Use your hand to do the masking, or a piece of cardboard cut to shape; but whatever you use keep it a couple of inches away from the surface of the paper, and constantly moving. This will avoid obvious hard lines between areas of normal exposure and those of extended exposure. Any area can be 'burnt in' in this way.

Printing papers come in several grades, from hard to soft. A hard paper produces a high contrast between light and dark areas of the print; a soft paper produces a low contrast. Whatever paper you use try to ensure that every print displays somewhere a good jet-black (in the deepest shadows) and an area of

just off white where the highlights are; a good range of tones between black and white makes for a good quality print.

When mixing and using chemicals you should always follow the manufacturer's instructions regarding the strength and temperature of the solutions.

Below: three grades of printing paper: grade 1, soft (top); grade 2, medium (centre), and grade 3, hard (bottom). The three prints were all made from the same negative.

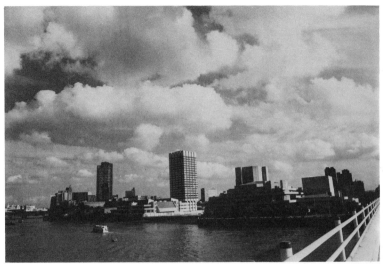

One film can do the lot

Some time ago one manufacturer introduced what was claimed to be the universal film. The idea was that it could be used to produce all types of photograph—colour prints, black and white prints or colour transparencies—making copies on to other kinds of film. Unfortunately the product was not a great success, and little is heard of the so-called universal film nowadays.

But recently there have been other developments, and it is now quite possible to concentrate on just one type of film, and to produce from it both colour and black and white prints and transparencies—although still not directly.

In fact, any colour transparency film can be the basis of your all-purpose photography. To begin with, take any one of the several 400 ASA transparency films now on the market. They will produce fine quality transparencies in almost any light, and they can be specially processed to increase their ASA rating. But what if you then want some colour prints made from your favourite transparencies? It is easy—there are now systems (Cibachrome is the best known, but Kodak produce one as well) which allow transparencies to be used to make prints directly onto special colour printing paper. The printing systems can be handled in a home darkroom; but there are plenty of processing houses offering the service, although some of them work by making a colour internegative and printing this in the normal way. But suppose you want black and white prints, not colour prints? Again, it is easy—if rather expensive. All you need to do is make, or have made, an internegative, which is simply a copy of your colour picture onto black and white negative material. From there you simply print the internegative in the same way

All the prints on these pages, both black and white and colour, started life as colour transparencies. The two colour prints below were produced via an internegative—in other words the colour transparency was rephotographed on to colour negative film, the prints being made from this in the normal way.

All four black and white prints on these pages were made from black and white internegatives. A colour transparency printed on to black and white paper will give markedly inferior results.

Left and below: bright colours such as greens and reds are reproduced brilliantly when printed directly from a transparency on to colour reversal paper. Glossy paper adds greatly to the impression of brilliance, as it reflects more light than textured papers and shows more detail.

as you would a black and white negative made conventionally in the camera.

Copying of any sort in photography is always liable to lead to an increase of contrast in the copy. And this increase is heightened if the original was taken in harsh lighting and was contrasty to begin with. You can minimize harsh contrast by shooting in soft lighting—an overcast day, for example, or by bounced flash indoors. An original shot in that way will copy with a satisfactorily large range of its tone intact.

If you are ever likely to want different types of picture from one original it is certainly best to begin with a colour transparency. A transparency is capable of recording more information than a colour print, inherently it retains more detail in the shadows and in the highlights. Professional photographers shooting for publication in magazines always use colour transparency film. If you begin with lots of detail you can afford to lose a little, but if you begin with relatively little detail there is no way you can add more.

Ideally you should use the correct film for whatever kind of picture you wish to produce, for then there can be no loss of quality resulting from copying (making internegatives) or from trying to compress the tones of a transparency onto a colour print. But as long as you are aware of the flexibility that photography has to offer you will be able to do very much more with your pictures.

Beyond photography

Photographs are increasingly being used as the basis for fine art productions—Andy Warhol's screen prints, made from Polaroid originals, are an example you may have seen. There are many ways of creating intriguing works of art from photographs. One very simple way is to make a collage, pasting together bits cut out of various photos.

If you have ever wanted to draw but have not been able to get the outlines right, photography can be your salvation. All you need is a pen (one with a nib, not a ballpoint) and Indian ink to draw over the lines on a black and white photo, preferably one made on bromide paper rather than the more modern resin-coated material. When the drawing is complete,

allow the ink to dry thoroughly, and then bleach away the photographic image with a special bleach which you can have made up by a local chemist to the following formula: 1·5% potassium iodide; 0·4% iodine; 98·1% water. Soak the image in clean water for a minute or so, then it is ready for bleaching. Lay the photo face up on a thick pad of old newspapers, and gently swab the surface with a cotton wool pad soaked in bleach. When the image has faded, leaving your line drawing, soak the picture in photographic fixer for as long as it takes to clear thoroughly, then rinse it in clean water for about half an hour. Do the fixing in a place with good ventilation—the smell is awful and irritating.

Not the kind of event you get the chance to photograph every day— unless you know how to cheat a bit. This is a collage, of course, made by using one photo as a background and sticking bits cut from others on to it. If you combine elements with the same perspective the whole thing can look deceptively matter-of-fact.

A line drawing made from a print by the method described on the opposite page.

Below: a collage does not need to be a joke to be effective. This one makes an unusual and appealing portrait. The series of photos of the child was varied in size by adjusting the height of the enlarger head very slightly in between prints.

The telephoto lens

A telephoto lens takes in a narrower field of view than the standard lens, and renders what it photographs on a larger scale. It magnifies in the same way as binoculars or telescopes do, and it does so by a degree which is dependent on the relationship of its focal length to that of the standard lens. Thus a telephoto lens of 135mm (the most commonly used) provides an image rather more than 2½ times larger than a standard lens of 50mm focal length; a 200mm telephoto will magnify the subject four times.

The telephoto distorts perspective in a way directly opposite to the wide-angle lens. Since it takes in a much narrower field of view than standard or wide-angle it excludes many points of reference and appears to squash the

different planes of the image together. So the telephoto lens can help to produce a crowded effect. For example, it could make a perfectly ordinary stream of cars look as though it were in a hideous traffic jam, simply because the telephoto excludes points of comparison (which would help you judge distance, perspective and scale) and brings the cars apparently much closer together. That impression is exaggerated because the more distant cars look disproportionately large in comparison with the closer ones.

The telephoto lens is of particular value to sports and natural history photographers. With it they can photograph subjects they cannot approach closely. But there is a limit to the usefulness of ever longer lenses, just as there is a limit to the usefulness of binoculars of very great magnification. The longer and heavier a telephoto lens is, the more difficult it is to hold it absolutely steady. Also, longer lenses usually have quite small maximum lens apertures, necessitating slowish shutter speeds. In sum, there is a distinct possibility of camera shake ruining many pictures. The more a subject is magnified the more any slight tremor of the lens will show up on the negative. About 200mm is the maximum focal length most people can handle without some support such as a tripod, or a wall or a fence on which to lean the camera.

Photographers who use a telephoto lens a good deal use what is known as a bean bag to help steady the bulky lens and camera combination. This is simply a small bag filled with dried beans, peas or rice. The bag is placed on a wall and the lens rested on it.

The huge majority of telephoto lenses are used with SLR cameras, which are increasingly equipped with through-the-lens metering, and in these cases problems of exposure do not arise. But a telephoto image is comparable to an ultra close-up image, in that the light from just a small part of the scene in front of the camera has to spread over the entire film area to make an adequate exposure. Obviously, that light will be diminished, and it will need to act on the film for a little longer to do its work. If your camera does not have TTL metering you should still increase the exposure: by how much depends on the degree of magnification, and the subject itself, but begin by opening up the lens one stop beyond what would be correct with a standard lens.

By excluding much foreground detail the telephoto lens presents a distant part of the scene before the camera as if it were close to. One consequence of this is illustrated below: the use of a 135mm telephoto has made the road seem to rise almost vertically behind the cottage – in fact it was quite a gentle slope.

Another consequence of the way a telephoto lens distorts perspective—the further away the subject is the shallower its depth becomes. A city street can be made to look jammed with cars when in fact traffic is moving fairly freely, simply because the cars look as if they are stuffed into a shorter stretch of road than they actually are.

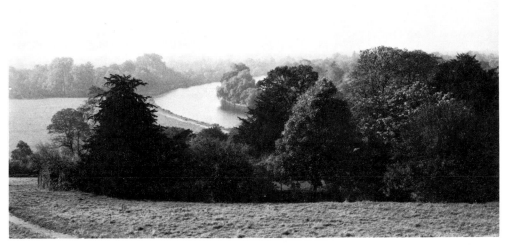

Left: Telephoto lenses take some getting used to, but when properly handled they can present the photographer with a very valuable aid to composition. Compare the two pictures left and below left: the first was taken with a standard 50mm lens, the second with a 135mm telephoto. You simply could not take the picture below using a standard lens, because by the time you had moved far enough forward to frame the picture with trees in the same way, you would have introduced a considerable impression of distance between trees and river.

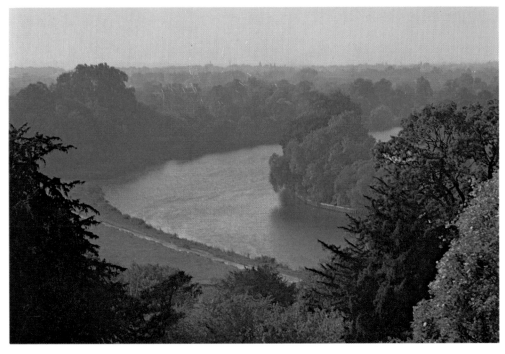

The wide-angle lens

A very wide-angle lens, the Nikkor 18mm. The wider the angle of view of a lens the more accurate does the curve and grinding of the glass have to be, and the more glass is needed. So, if they are to be of high quality, very wide-angle lenses are necessarily expensive.

The so-called standard lens is designed to give a view which roughly equals that of the human eye: in fact the eye sees in a much wider angle, but objects at the edges of our vision are not perceived in detail. The standard lens thus produces perspective and scale effects which look quite normal in transparency or print form, provided the print is made from the whole area of a negative (cropping away part of the image produces a telephoto effect).

The wide-angle lens takes in a field of view of 60° or more—or as much as 180° in the case of the fish-eye lens, which is an ultra-wide-angle. The commonest wide-angle lenses have focal lengths of 35, 28, 24, and 20 or 21mm. From the same viewpoint, a wide-angle lens renders the scene before it on a smaller scale than does the standard lens: it thus gets more into the picture. It also brings less depth of field limitations, and the characteristic wide-angle photograph is sharp all over. Less focusing accuracy is necessary, for if the lens aperture is stopped right down it is possible to have everything in focus from around 60cm (2ft) to infinity.

Because it takes in such a wide angle of view the lens may at times appear to distort the subject. If you take a picture of someone two metres (6-7ft) or so away, with a standard lens, the picture will show the upper part of your subject almost filling the viewfinder without any great degree of distortion. But if you switch to a wide-angle lens you will take in much more of your subject; and any object near to the camera, including his legs or arms if they are outstretched, will seem disproportionately larger. This distortion is often used deliberately to give an illusion of depth within the picture. And because the lens does 'get more in' it is possible to move very close to objects in the foreground, thus altering the ratio of the distances between them, the camera and the other parts of the picture: this can give an impression of great changes in scale.

Right and opposite page: these shots show how you can use a wide-angle lens to get more in the picture where space prevents you from stepping back. The picture on the opposite page was taken with a standard 50mm lens, that on the immediate right using a 28mm wide-angle lens.

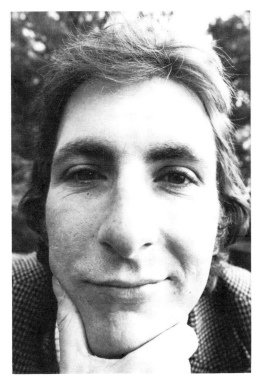

Wide-angle lenses introduce their own characteristic form of distortion. Objects in the foreground become disproportionately larger the closer they are to the camera.

Far left: the distortion can be put to humorous use as in this portrait, where the subject has been given a boorish, derisive look.

Left: an attractive feature of this horse is its long, flowing mane; in this picture a wide-angle lens was used to make it more prominent.

The real value of the wide-angle lens is in its ability to include more than the standard lens. This makes it invaluable when pictures have to be taken in a restricted space, and when photographing the interiors of buildings. Provided the photographer takes care not to have any elements of his picture too close to the camera, pictures can be taken without severe distortion.

Two forms of rather bizarre distortion do become noticeable with ultra-wide-angle lenses. Firstly faces (and indeed other objects,

although it is most evident with faces) at the very edges of the picture tend to become drawn out of shape; avoid this problem by having faces that matter placed at or near the centre of your pictures. Secondly, with cheap wide-angle lenses you may get curvature of what should be straight lines at edges of your pictures. This is particularly evident with lens attachments designed to convert standard to ultra-wide or fish-eye. The only cure is to avoid having important subject matter near the edges.

Changing things with lenses

A choice of lenses introduces great versatility into your photography. Opposite page, top and centre: the same scene taken with a 135mm telephoto, a 50mm standard, and a 28mm wide-angle lens. The telephoto image has been cropped in to the subject, enhancing the telephoto effect.

Below and opposite page, bottom: where there is no background detail the telephoto lens can be used without fear of distortion, effectively bringing the photographer nearer to the subject. Although these two photographs were taken simultaneously by two cameras standing side by side, no one could easily prove that the telephoto shot was not taken with a standard lens from a great deal nearer to the aeroplane—it is only the direct comparison which gives the game away.

They say the camera never lies. But it does, sometimes outrageously. And never more than when the photographer is confusing the senses by distorting perspective.

It is perspective which helps us orientate ourselves in our surroundings: it goes through our mental computer so that we can determine distances, heights, the relationship of one object to another, our own relationship with everything around us. The way we perceive perspective is dictated by the angle of vision our eyes take in.

The standard lens of a camera sees things in much the same perspective as our eyes—although as we have binocular (two-eyed) vision we are able to use our eyes as a sort of rangefinder, and we can assess distance much more accurately than a photograph can suggest it. Distance may be suggested in a picture by distance haze, or by the size of various known objects, of course; but even where distance is unclear a photo taken with a standard lens will look fairly unremarkable as far as perspective is concerned.

It is when the photographer switches lenses that deception creeps in. This is how it works. Ask two people to stand at a distance from you—one at five metres (15ft) away, the other ten metres (30ft) distant. You know the size of

a human being so you will have no difficulty in appreciating the sizes and distances of the people in this case. But now move very close to the nearer one: he will occupy a very much larger part of your field of vision than the other. Your brain, knowing that they are both normal people of average height, will correct that imbalance. But a wide-angle lens would include all of the closest figure as well as the distant figure, and would make one look emphatically larger than the other. And if the two were objects whose size you did not know you could easily be deceived. A wide-angle shot of a tiny swimming pool with a hotel beyond, taken with the camera very close to the pool, would make that pool seem huge, like a lake.

Now move some distance away from your two subjects; the further back you move the more the size difference between them diminishes, so that they begin to look as if they are the same size again; but your mind will tell you that there is a distance between them. A telephoto lens photograph will actually give the impression that the more distant subject is quite a bit closer than he is. That is because the telephoto takes its pictures within a narrow angle of view, thus seeming to bring the further subject in much closer than it really is; and it

would destroy the impression of distance between the two people. You, knowing that there was a gap of 5 metres (15ft) between the two, would expect the distant one to look smaller, and seeing them almost the same size you would immediately sense something strange in the perspective of the picture. However, suppose the two objects photographed were not people, but some objects you were not familiar with: it is clear that the apparent size of the more distant object would be greatly exaggerated. And this effect frequently comes into play in landscape photography, when a modest hill in the background is 'pulled forward' and made to seem like a mountain, towering over foreground objects.

Add on bits

Once you have the basic camera body and lens combination there is practically no end to the ways in which you can extend the frontiers of your own photographic range. All of the bits and pieces that you can buy will make your outfit more versatile—some by adding a whole new dimension, like the flash unit (right) or the bellows unit for close-up photography (bottom). Other less costly additions, such as the Pentax range of special effects filters (below), can represent a splendid investment if you enjoy experimenting with light and colour and creating bizarre effects for their own sake.

Throughout this book the emphasis has been on the importance of light, and it has repeatedly been stressed that good pictures depend on its quality and its quantity. The section on filters tells how the light can be altered before it passes though the lens—how some can be diminished, or coloured, how it can be caused to scatter for a soft focus effect. It is important to remain aware of light as a force, as rays of energy leaving some light source—the sun, a flash unit, lamp or candle—and striking the subject before being reflected into your lens. By using a starburst filter you can make the light from individual sources flare outwards, so that each lamp appears like a star. And by using a prism lens you can multiply the image so that it appears several times on the film.

There is no need to limit yourself to those lens attachments on the market, or to the techniques most readily suggested by your camera controls; think up original ways of interfering with and altering the rays of light, and you could produce intriguing effects. What would a picture look like if you shot through a rolled-up tube of highly reflective kitchen foil, or through hammered glass? And what would be the effect of shooting through lace curtains—from inside into the garden?

Use your imagination to help you produce pictures. There is no light, however bright, however dim, in whatever way distorted or interfered with, which cannot be recorded by the camera.

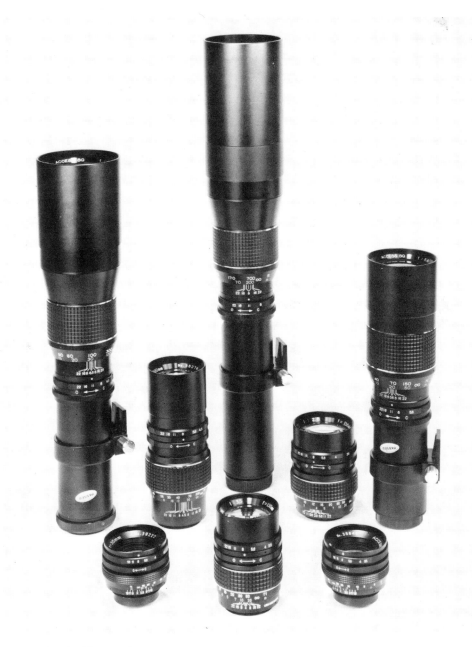

If adaptability is what you look for in a camera, then one of the many 35mm single lens reflex cameras will almost certainly be your choice. Ranges of lenses are made by manufacturers for their own cameras, but the single lens reflex is so popular that independent makers now produce ranges of interchangeable lenses which will fit most makes. This impressive display is the Access range, from 35mm wide-angle to 500mm telephoto.

Below left: this Pentax 110 SLR camera has its own range of accessories— filters, close-up lenses, telephoto and wide-angle lenses, powered film advance, flash unit, and lens hoods for the various lenses. This comprehensive outfit could tackle just about anything.

Below: owning a zoom lens is like having a complete set of telephoto lenses all rolled into one. This is the Tamron SP 70-210mm, shown complete and in cut-away.

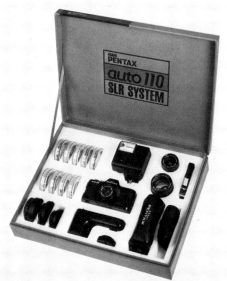

Finding a purpose

Nothing stimulates a photographer to take better pictures more than having a purpose. Aimless shooting will eventually lead to dissatisfaction with your output. If you think of photography as a language (pictures do, after all, tell stories and give up information) you can imagine how pointless it would be to mumble words without putting them together into sentences.

Using photography to make a growing record of your family, or in support of some other hobby, is certainly putting it to good purpose. But you might eventually like to become more ambitious. You could begin by making a survey of local beauty spots—or even local ugly spots. And you could offer your services to local organizations to provide a documentary series on their work. Such selections of pictures can be most valuable for promotion. Try the local amateur dramatics organization—they would surely be delighted to have a permanent record by which to

Photography for its own sake can be immensely rewarding, but many people derive an even greater satisfaction from setting themselves particular aims—not to the exclusion of general purpose photography, of course, but as a way of putting their photographic skills to good use in the service of some other interest. All the pictures on these pages were taken by an amateur with a keen interest in motor racing. If you have ever tried taking pictures at these events you will know how difficult it can be to get close enough to the action. So, showing a bit of initiative, he went to a pre-race practice session (pits road 'walkabout') and took his pictures there.

remember their various productions and their main characters.

It is always a good idea to make one particularly purposeful set of pictures—a photographic record of all your valuables. This will be a great help for insurance purposes, and an even greater help to the police if you are unfortunate enough to be burgled.

My own purpose is rooted in the Western Highlands of Scotland. For several years I have been returning there, two or three times a year, at different seasons, slowly compiling material for a book on the quite fantastic atmosphere of the area. Each time I find different lighting conditions, and ever more stunning landscapes to picture. And when I return I spend weeks examining each new set of images, pondering how I could have done something better. My obsession has led me towards a very satisfying knowledge of, and affinity with, the area, and each trip there creates its own necessity for a return trip. For example, on a recent journey I photographed salmon leaping up one of the wild waterfalls which dot the Highlands. I took some twenty pictures, each just as a fish leapt. In examining my pictures I found two were *nearly* right: they showed good outlines of the fish, but the stubborn creatures were never exactly where I would have liked them in the pictures. So, another trip, another time will find me trying to better what I have got.

Having a purpose makes you think very hard about the pictures you want to take, it makes you consider very carefully the techniques and equipment you will need to use to get them. And that is better than scratching your head and wondering what to photograph next.

Glossary

A

Angle of view the widest angle at which light rays entering a lens will still give a full image on the film plane.

Aperture the opening in a lens which controls the amount of light passing through the lens; usually variable in diameter.

ASA (American Standards Association) indicates the speed, or sensitivity to light, of film. The higher the ASA number, the faster the film. Film speed doubles as its ASA rating doubles; 400 ASA film, for example, is twice as fast as 200 ASA film.

Automatic exposure control automatic adjustment of either lens aperture or shutter speed to suit the lighting conditions.

B

Back lighting lighting from behind the subject.

Bellows lightproof folding tube which can be fitted between the lens and the camera body for close-up photography.

Bounced flash flash illuminating a subject indirectly by reflection off a ceiling or a wall.

Bracketing taking a series of pictures instead of a single one, varying only in the exposure.

Bromide paper most common type of black and white printing paper.

B setting setting at which the shutter will remain open as long as the shutter release remains depressed.

C

Cable release flexible cable which can be fixed into the shutter release button, helping reduce camera shake.

Cibachrome process for making colour prints from transparencies.

Colour temperature measurement of the colour quality of light.

Contact sheet sheet of prints made the same size as the negatives with the printing paper in direct contact with the negatives.

D

Depth of field distance between the nearest and furthest point from the camera within which the subject is in focus.

Developer chemical fluid that converts the latent image on exposed light-sensitive material to the visible image.

Differential focusing setting the lens aperture for minimum depth of field, to limit focus to a particular subject against a background and/or foreground that is out of focus.

E

Electronic flash flash produced when an electric current stored in a capacitor is discharged into a gas-filled tube.

Electronic shutter shutter where the period between opening and closing is regulated automatically.

Enlarger type of projector used to focus a negative image on to printing paper to produce prints of different sizes by increasing or decreasing the distance between the negative and the paper.

Exposure the amount of light that reaches the film (controlled by the lens aperture) multiplied by the length of time (controlled by shutter speed).

Exposure latitude the margin of error within which over- or underexposed negatives or prints are still acceptable.

Exposure meter instrument that measures the amount of light being reflected by a subject.

Extension tube tube that fits between lens and camera body to extend the range of focusing for close-up photography in a series of fixed steps.

F

f/stops sequence of numbers engraved on the lens barrel equivalent to the focal length divided by diameter of the aperture.

Filter transparent disc which modifies light passing through it. Colour filters absorb certain wavelengths of light; this has the effect of causing colours complementary to that of the filter to darken and similar colours to lighten.

Fish-eye lens extreme wide-angle lens.

Fixing stage in film and print processing during which the image is stabilized so that it is no longer affected by light.

Flare light scattered by reflections within the lens. May appear as a series of blobs each in the shape of the aperture.

Focal length the distance between the back of the lens and the focal plane when the lens is focused on infinity.

Focal plane the plane at right angles to the lens axis on which a sharp image is formed by the lens and at which the film is situated during exposure.

Focus the point at which light rays from the lens converge to give a clear and sharp image of the subject.

G

Glossy paper printing paper with a smooth, shiny surface.

Grade measurement of the capacity for contrast of a particular range of printing paper. The higher the number the greater the contrast.

Grain tiny clumps of black silver formed in an emulsion after exposure and development.

Guide number number used to determine the aperture required with any given unit-to-subject distance when flash is used.

H

Highlights lightest parts of the image; the opposite of shadows.

Hot shoe accessory shoe on top of a camera body with guide rails to hold a flash unit. It makes an electrical connection between flash unit and shutter mechanism, so that the flash is fired at the right moment.

I

Instamatic camera basic camera which takes cartridges of film, and so can be loaded instantly.

Instant photography system which produces a processed print immediately after exposure, direct from the camera.

L

Latent image the invisible image formed on the emulsion when a photograph is taken.

M

Macro lens lens especially designed for extreme close-up photography.

Monochrome technical term for black and white.

N

Negative photographic image in which subject highlights are dark and shadows light; used in an enlarger to make a positive image on printing paper.

P

Panning the technique of swinging the camera to follow a moving subject so that the subject stands out against a blurred, streaked background.

Plate camera camera originally designed for use with glass plates; now used with large-format film.

Plates large-format light-sensitive materials with the emulsion coated on glass (now rarely used).

Polarizing filter colourless filter that absorbs polarized light; used to cut out glare from reflected light.

Print an enlarged image produced on paper coated with a light-sensitive emulsion; made from a negative in an enlarger.

Projector piece of equipment used to display enlarged images, preferably on to a screen.

R

Rangefinder a focusing system that determines the distance from camera to subject.

'Red eye' effect producing red eyes in colour portraits taken by flash. The retina, which is red, reflects flash light into the camera lens if the unit is too close to the camera-lens axis.

Resin-coated paper printing paper which has a water-repellent base. It is faster to process than regular fibre paper, needs less washing and dries more quickly.

Retouching hand treating of negatives or prints to remove spots and blemishes.

S

Safe lighting low darkroom lighting of a suitable colour that does not affect the paper being used.

Single lens reflex (SLR) camera which allows the user to see in the viewfinder the exact image formed on the film by means of a mirror behind the lens. The mirror is raised when the shutter is open.

Slave unit relay mechanism which fires other flash units simultaneously with the unit on the camera.

Slide *see* Transparency.

Soft focus romatic effect achieved by the use of a soft focus filter or other attachment placed either on the camera or enlarger lens.

Split-image focusing focusing system in which a small part of the image is split and remains out of alignment until the lens is correctly focused.

Standard lens camera lens which will give an angle of view and a scale that approximates to human vision (usually 50mm in single lens reflex cameras).

Stop bath chemical or water bath used after development and before fixing; stops development by neutralizing the developer.

Stopping down reducing the lens aperture.

T

Telephoto lens lens with a narrow angle of view, which effectively magnifies distant objects.

Test strip strip of paper on which a series of trial exposures is made to test for correct exposure time.

Through-the-lens (TTL) metering a system of measuring only the light that actually passes through the lens, leading to a very accurate exposure.

Time exposure a long exposure made by opening and closing the shutter manually with the shutter release at the B setting.

Transparency positive image, usually in colour, made using reversal film.

Tripod three-legged adjustable camera stand.

Tungsten lighting artificial lighting such as that given by ordinary domestic lamp bulbs.

U

Uprating overdeveloping a film to compensate for (deliberate) underexposure; effectively increases film speed.

W

Wide-angle lens lens with wide angle of view.

Acknowledgements

Jacket photograph by Paul Williams

The author and publishers are grateful to the following for supplying photographs for this book

Catherine Blackie, Peter Crump, Geoff Dufeu, Philip Evans, Karel Feuerstein, Hazel Harrison, A. H. Johnson, Leigh Jones, Malcolm White, Paul Williams

Index